Owen Sound Ontario in Photos, Saving Our History One Photo at a Time

Photography
by Barbara Raué
2012

Series Name:
Cruising Ontario

Book 8: Owen Sound

Cover photo: Reflections in the quiet river

Owen Sound

Owen Sound is located on the southern shores of Georgian Bay in a valley below the sheer rock cliffs of the Niagara Escarpment. The city is located at the mouths of the Pottawatomi and Sydenham Rivers. It has tree-lined streets, many parks, and tree-covered hillsides and ravines.

This area of the upper Great Lakes was first surveyed in 1815 by William Fitzwilliam Owen and Lieutenant Henry W. Bayfield. The inlet was named "Owen's Sound" in honour of the explorer's older brother, Admiral Sir Edward Owen.

The city was first known as Sydenham when it was settled in 1840 by Charles Rankin. Prior to his arrival, the area was inhabited by the Ojibway people. In 1851 the name was changed to Owen Sound. For much of its history, it was a major port city known as the "Chicago of the North."

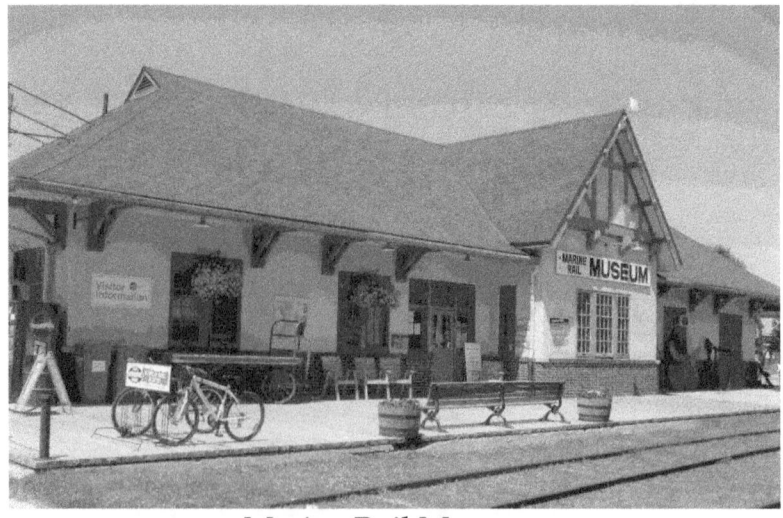

Marine Rail Museum

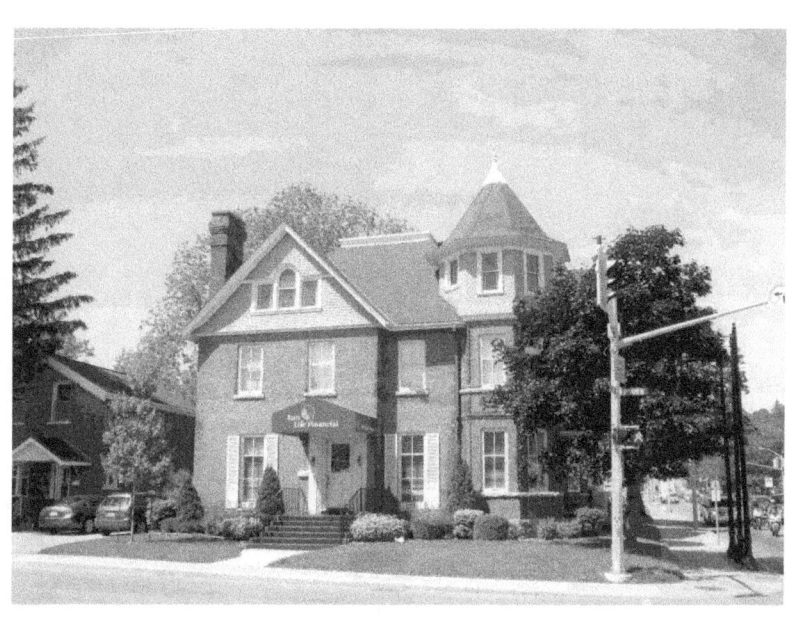

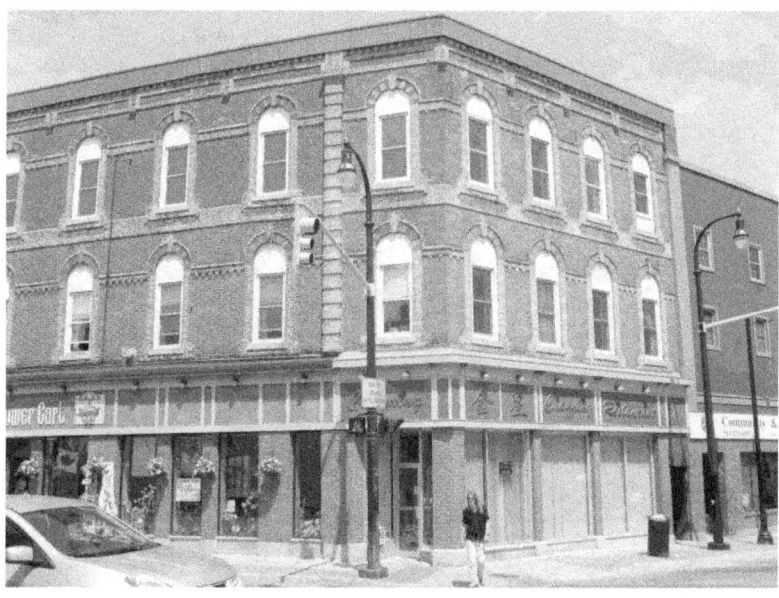

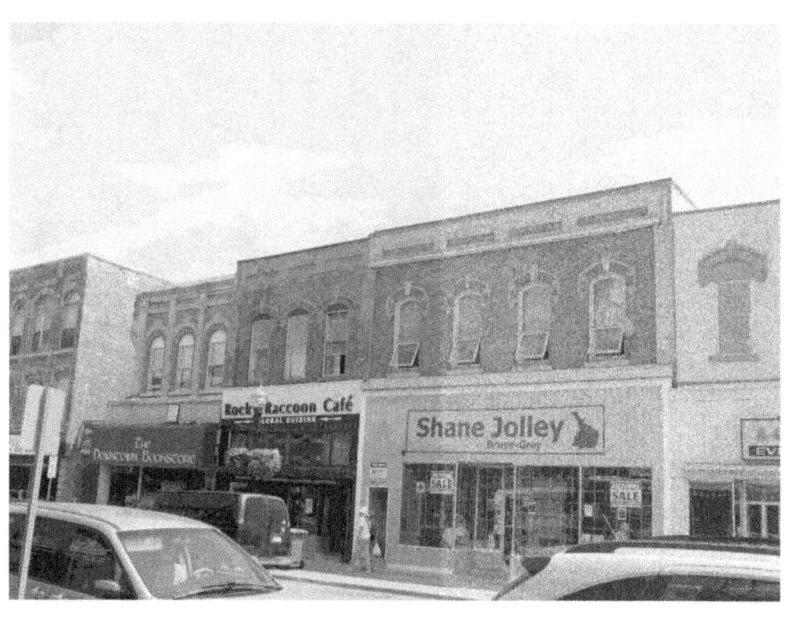

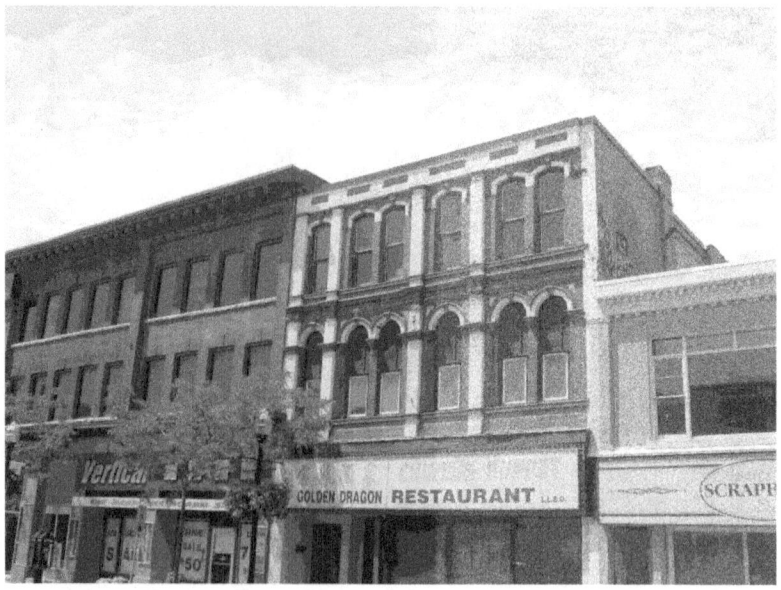

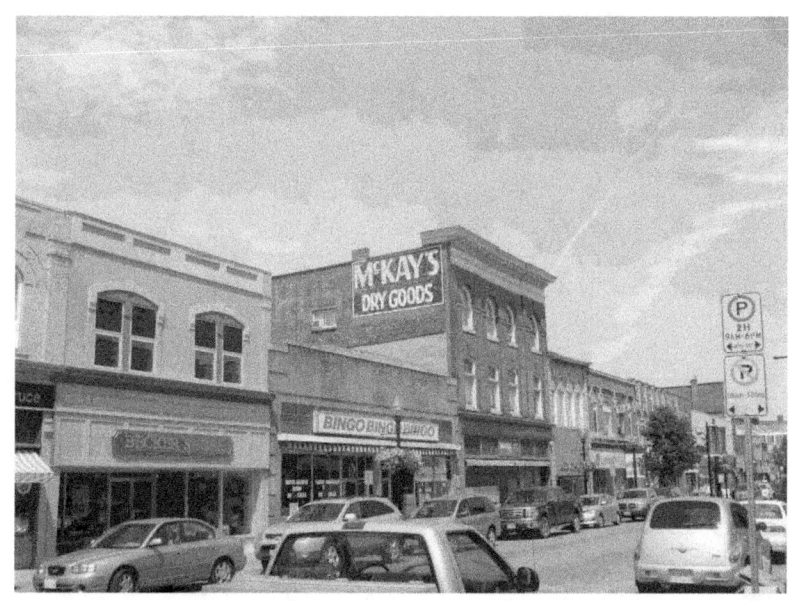

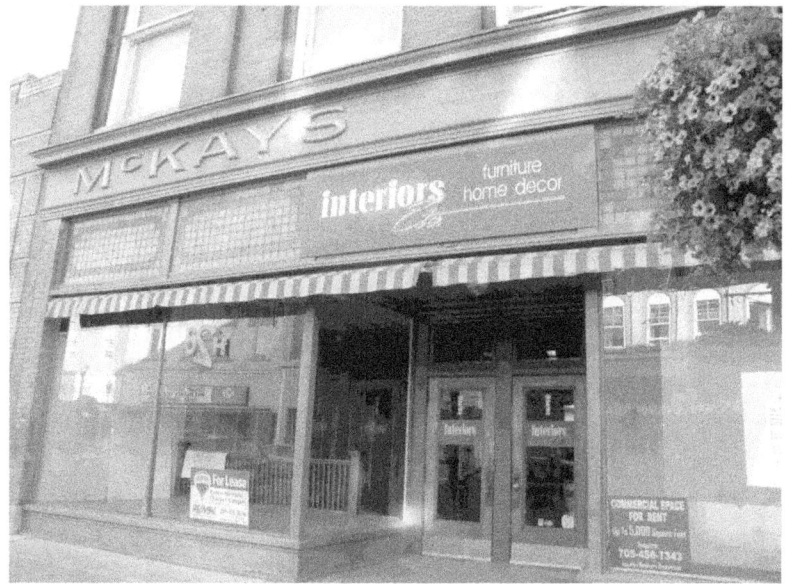

G. B. Ryan & Co. 1905-1924
McKay Bros. Dry Goods 1924-1989

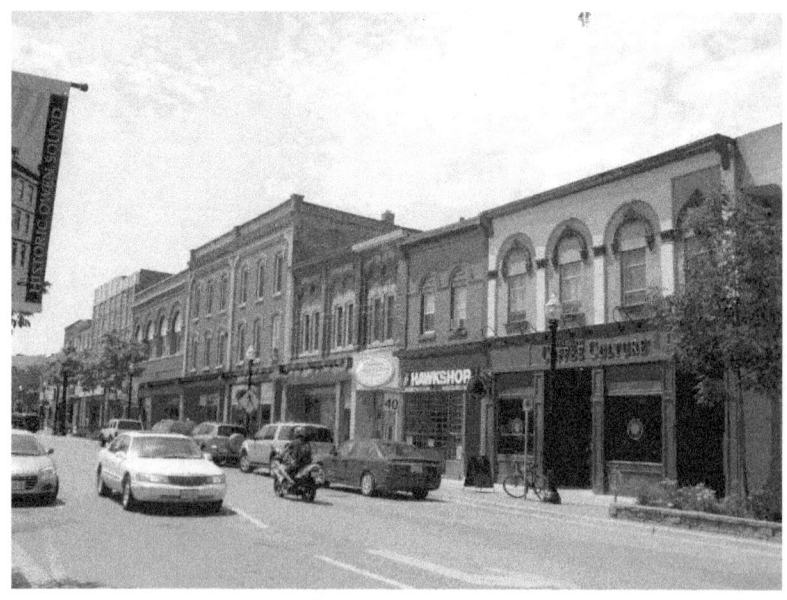

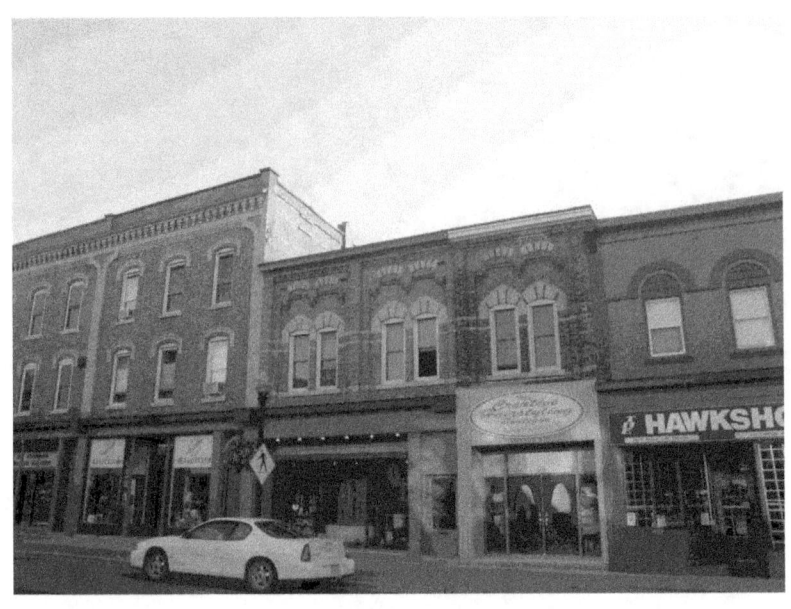

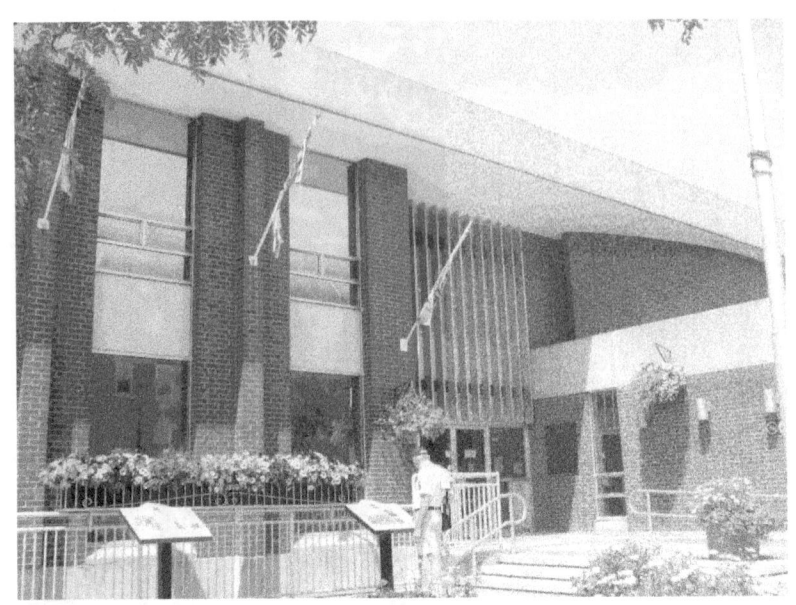

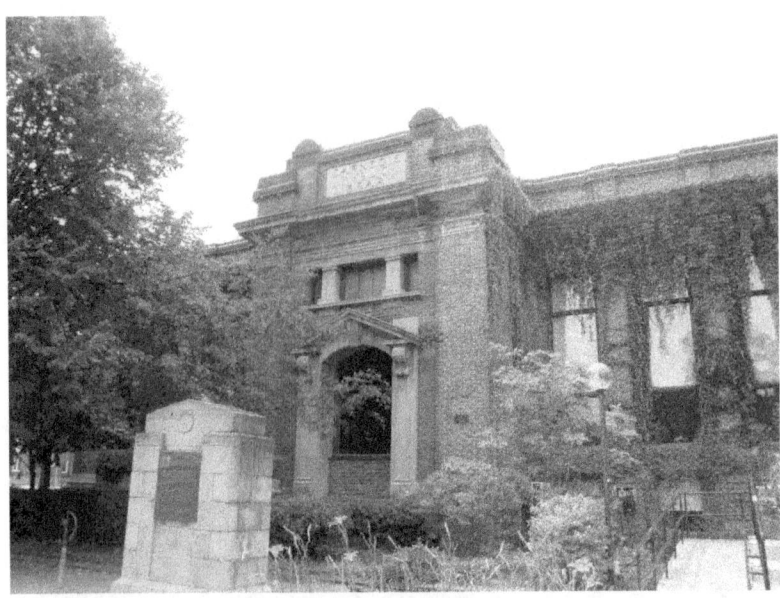

Carnegie Public Library, 1st Avenue West
opened February 3, 1914

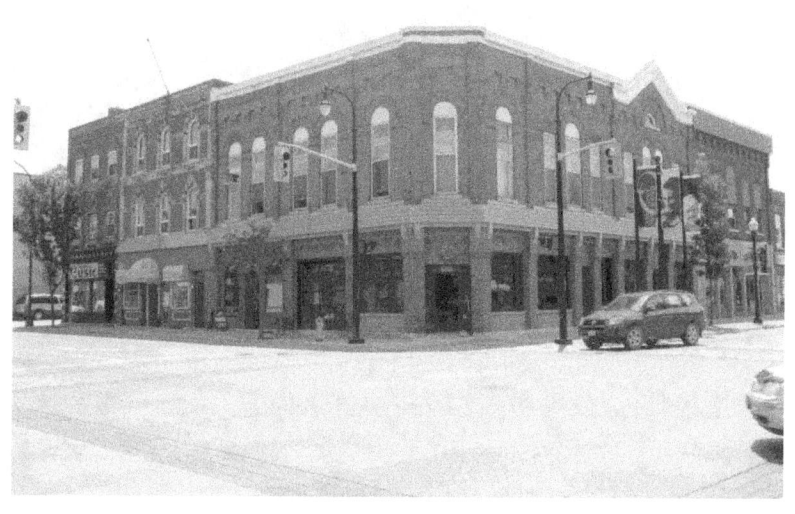

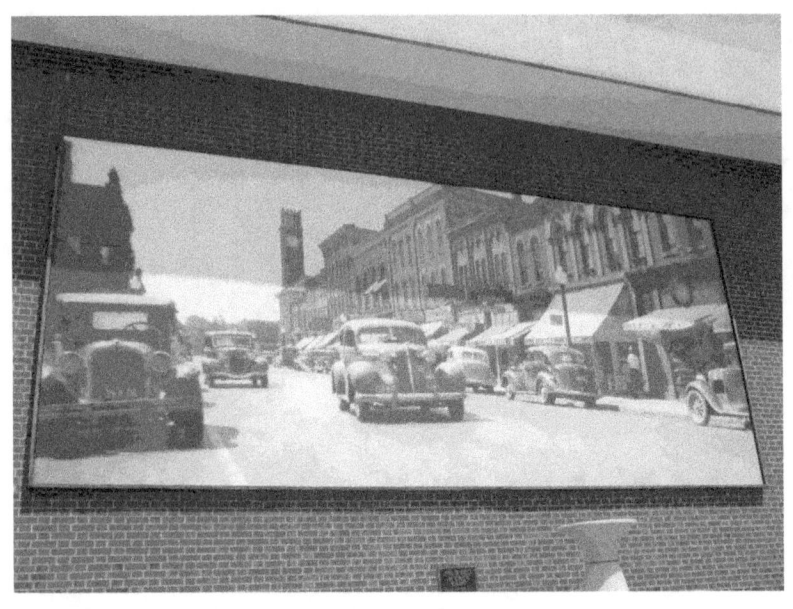

#720

#712

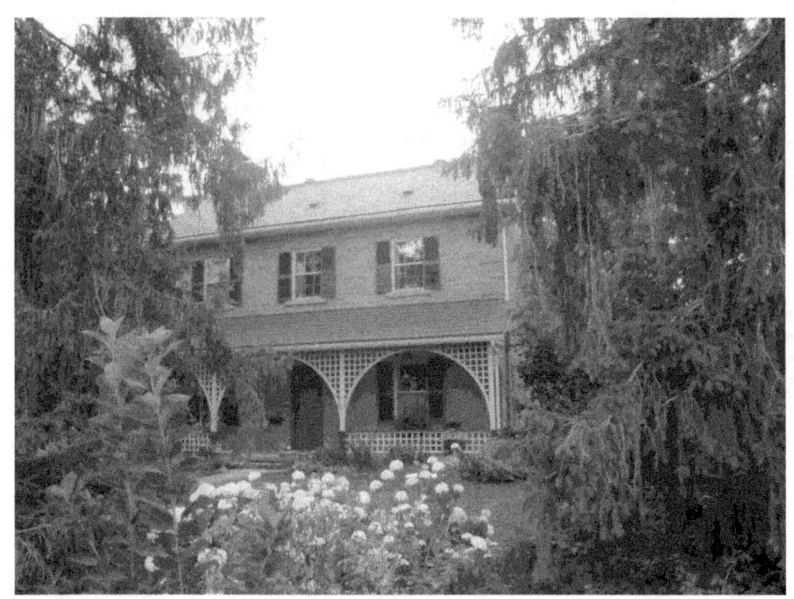

#682

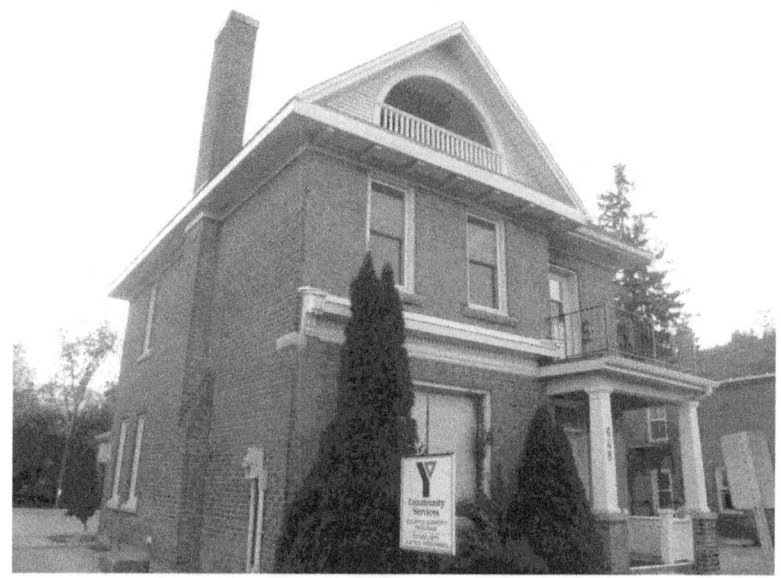

#648

#529

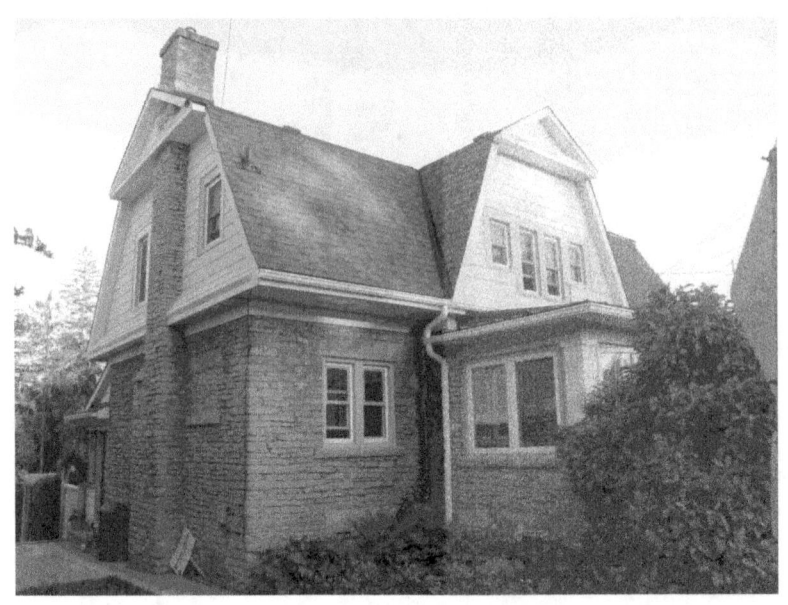

#239

#250

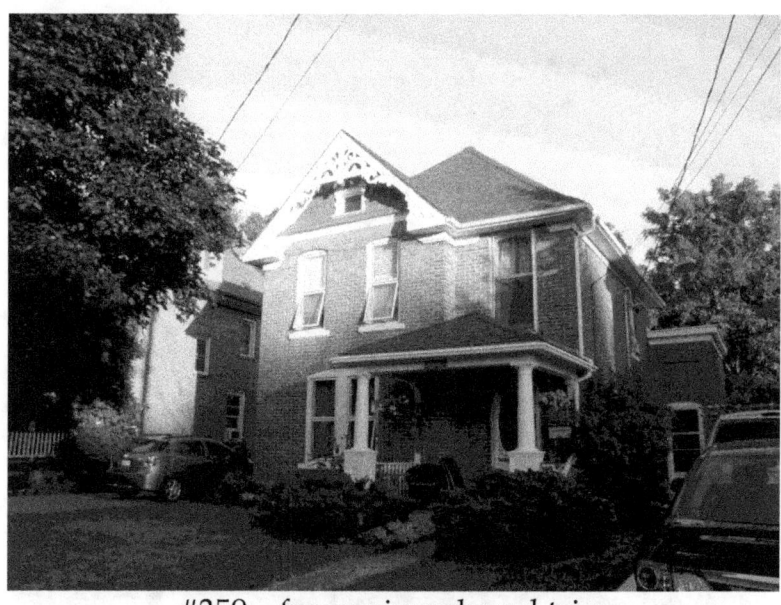

#359 – fancy gingerbread trim

4th Avenue and 5th Street

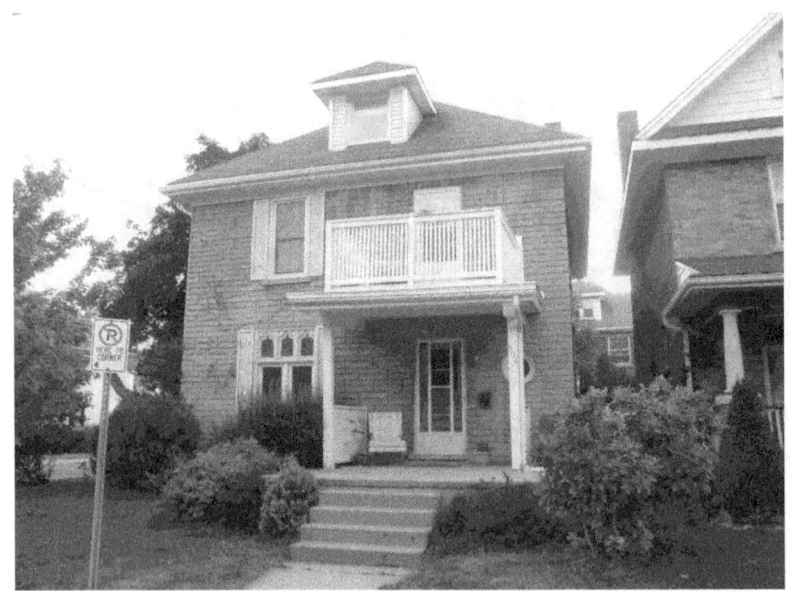

#504

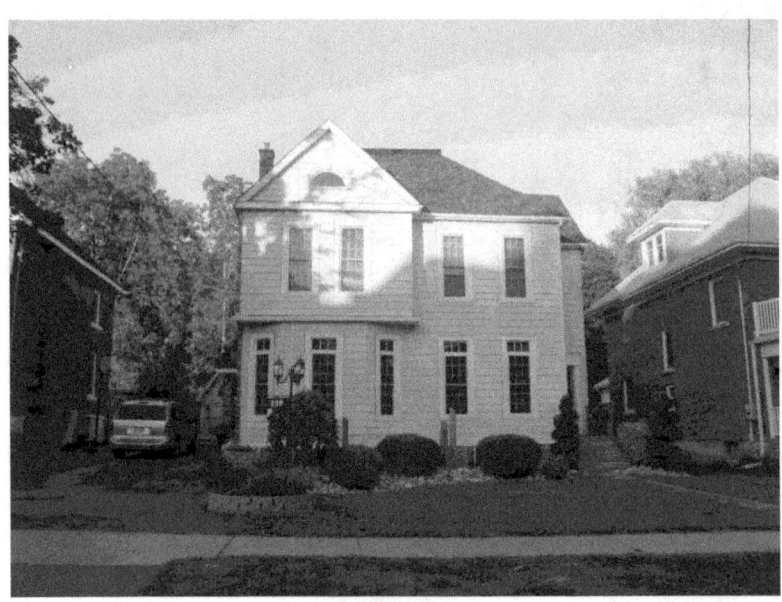

#559

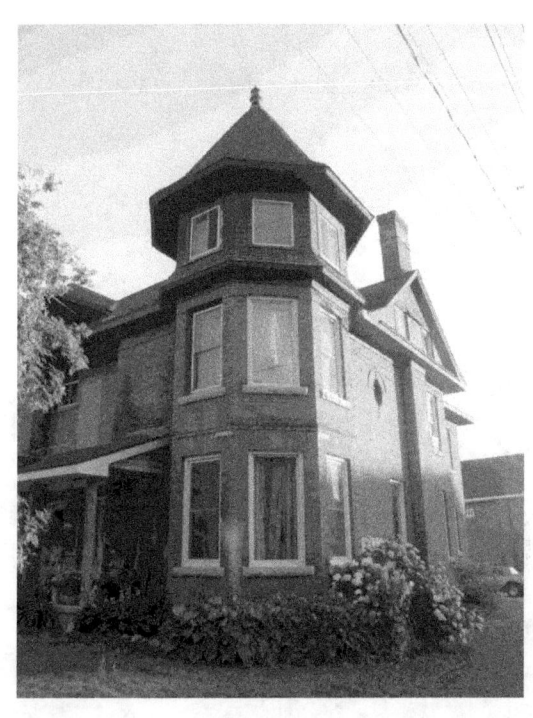

Corner of 4th Avenue East and 6th Street East

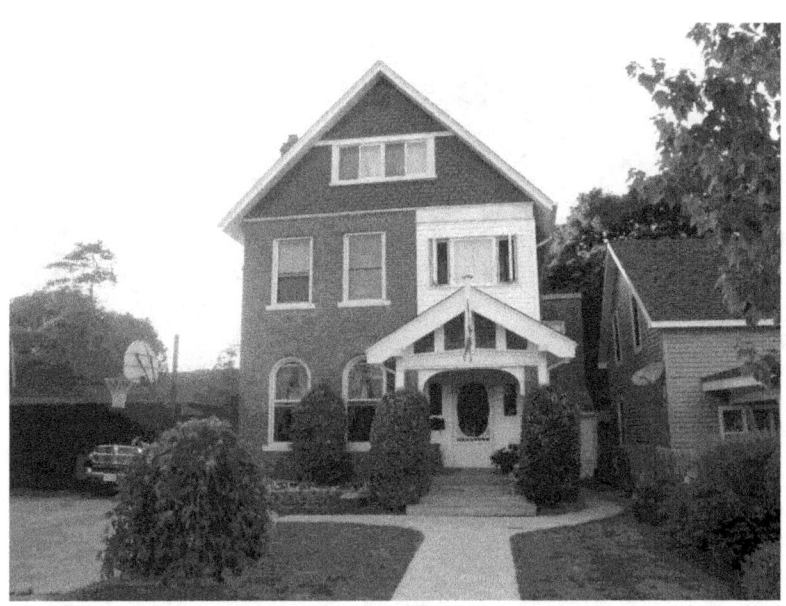

6th Street East and 3rd Avenue

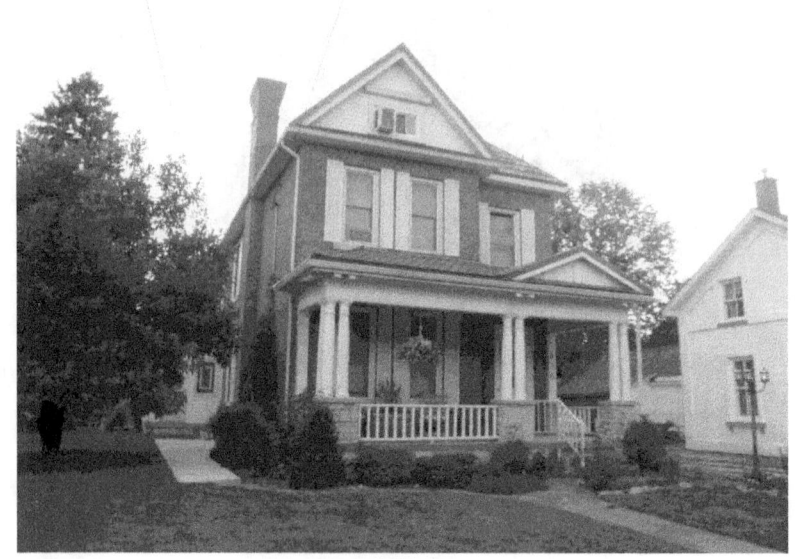

#626

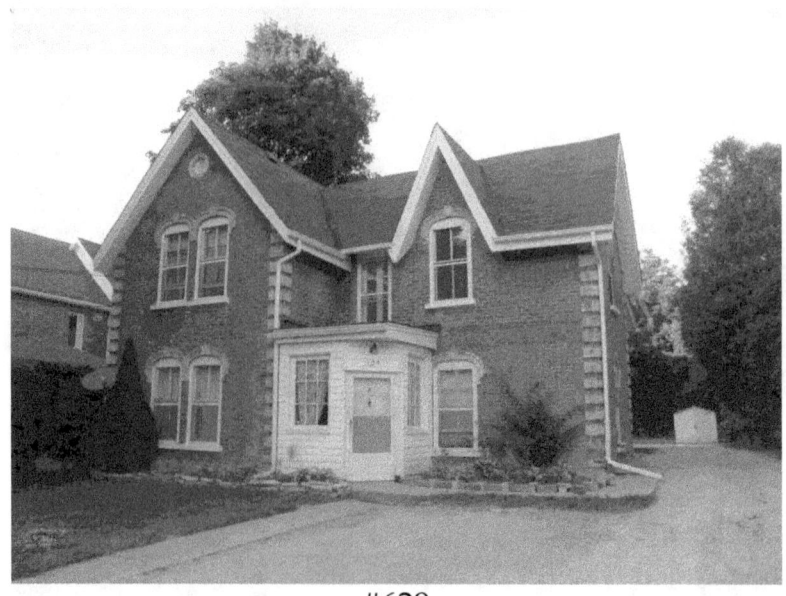

#629

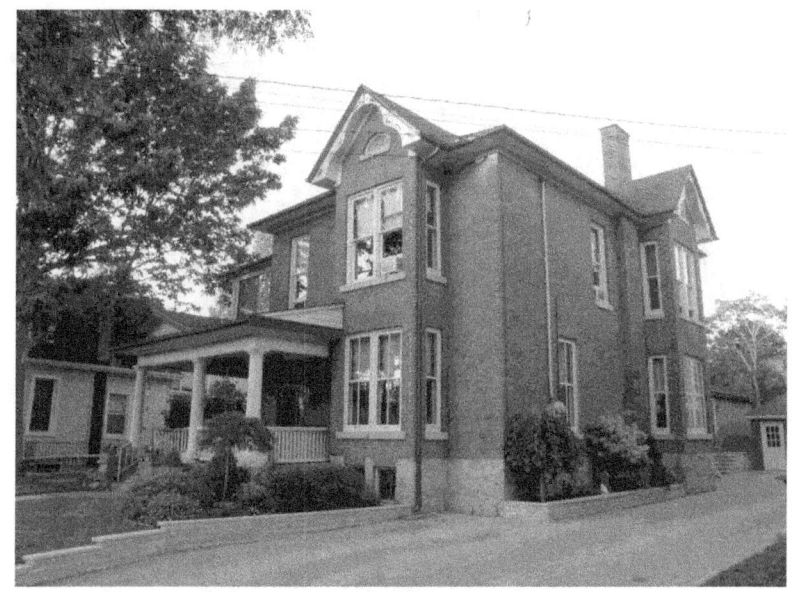

#665

7th Street East and 3rd Avenue

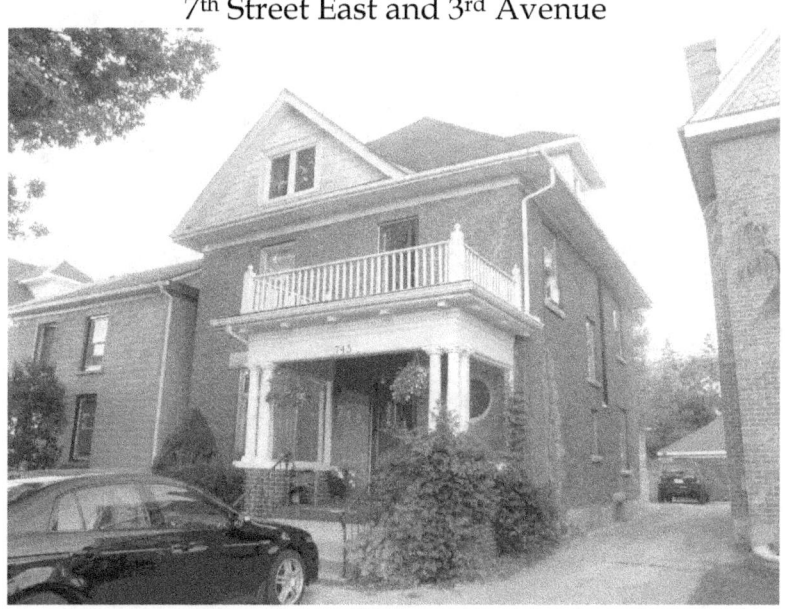

#745

#757

3rd Avenue and 8th Street East

Old stone building

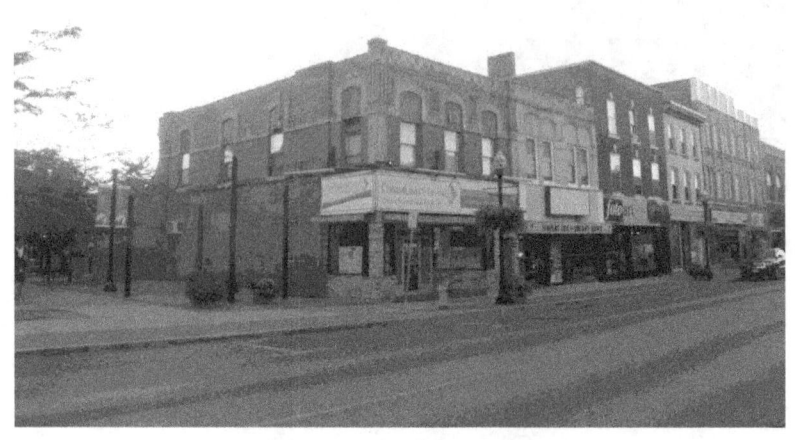

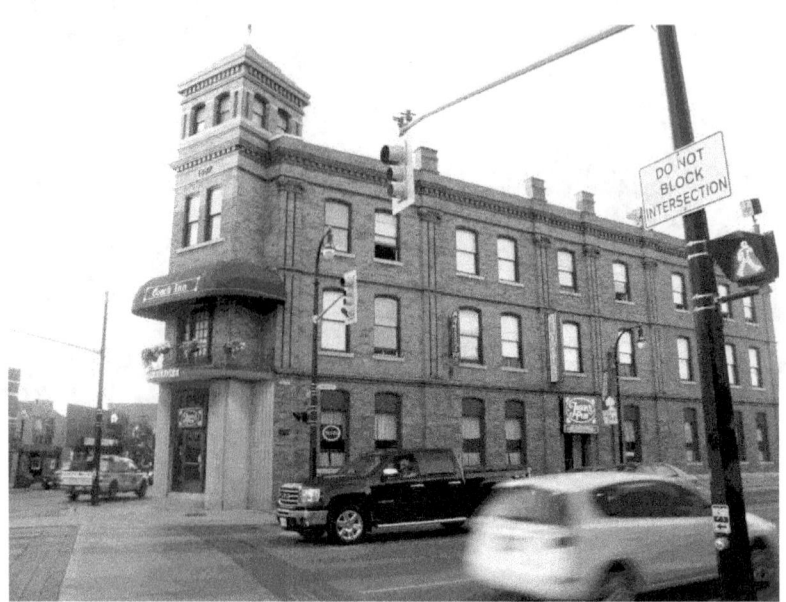

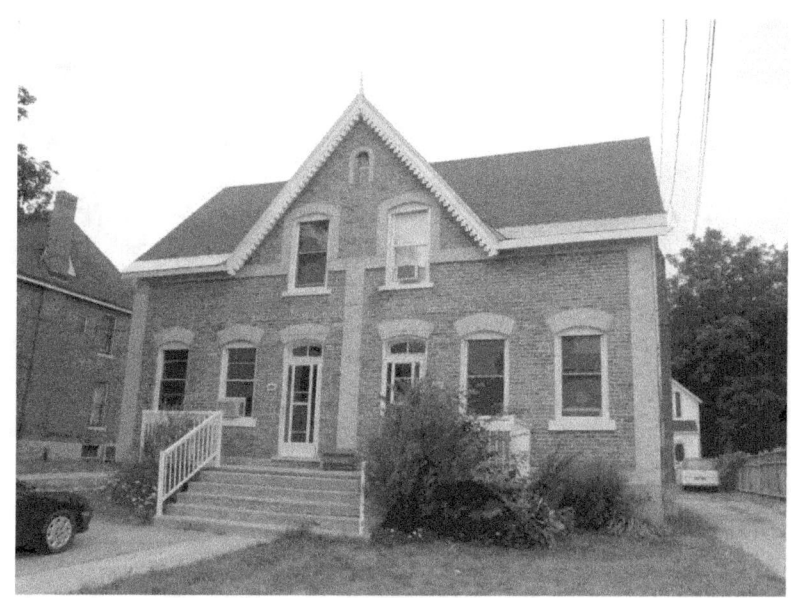

#960

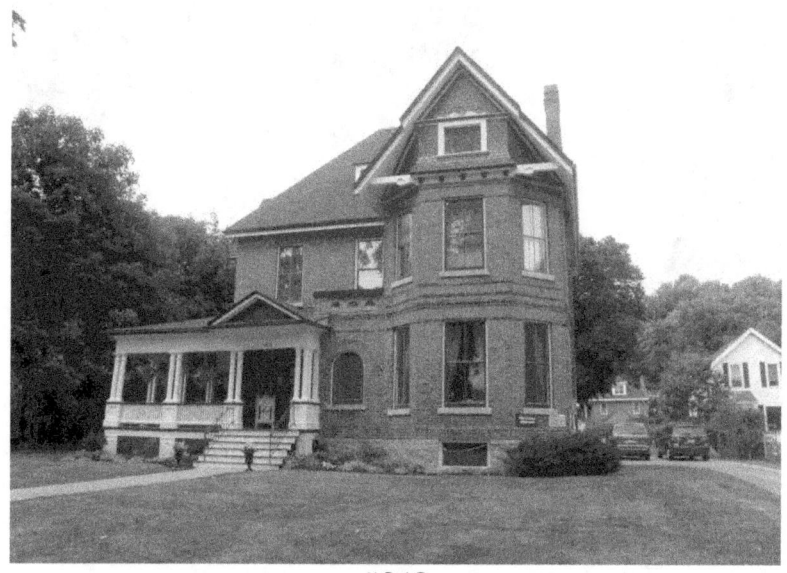

#948

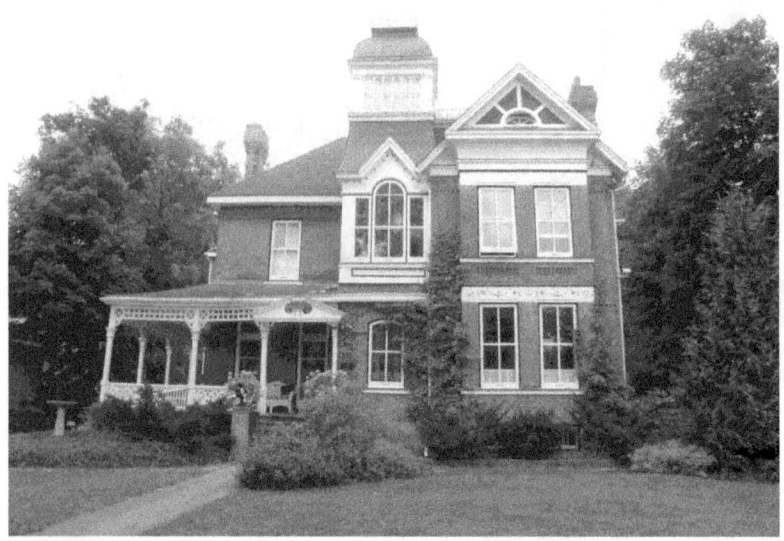

#932 3rd Avenue West - Former U.S. Consulate – 1890

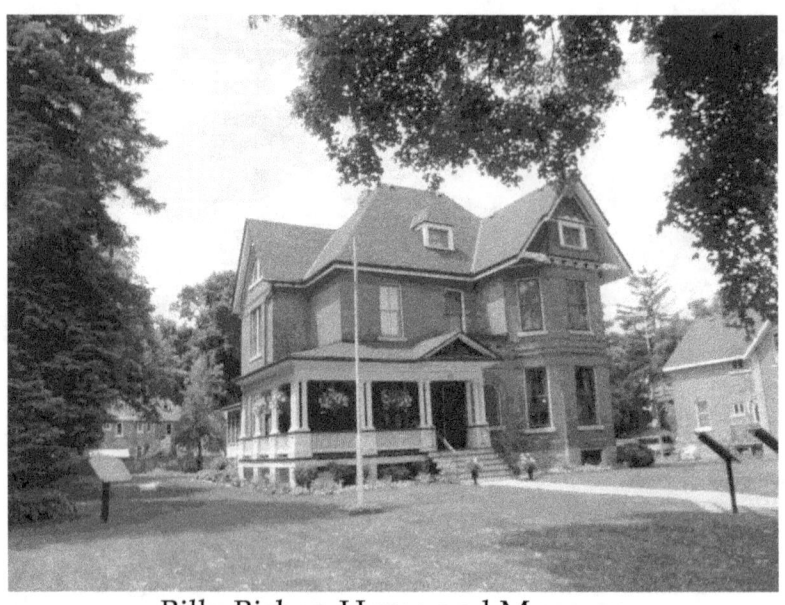

Billy Bishop Home and Museum
948 3rd Avenue West

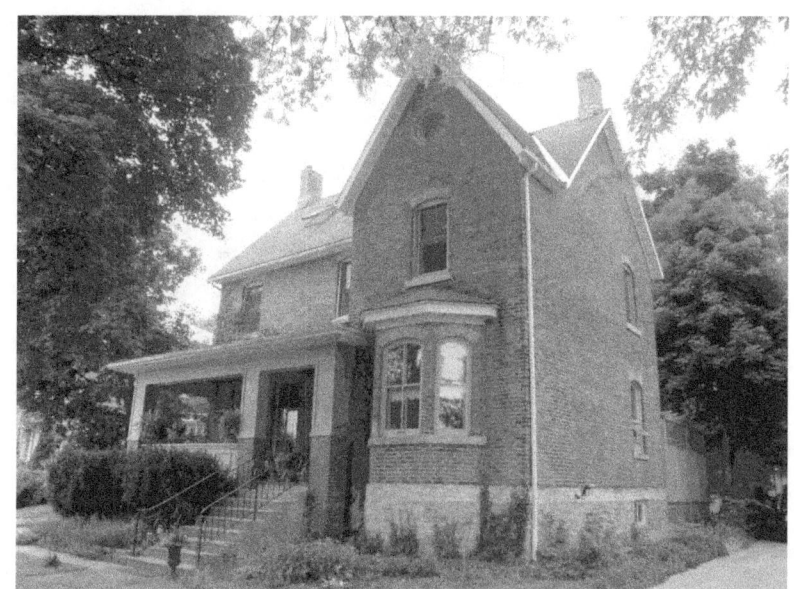

#922

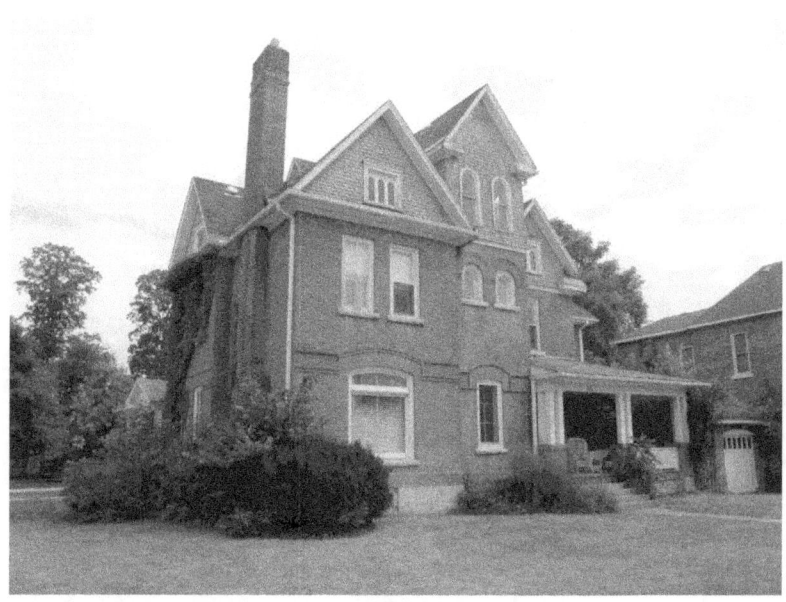

#284

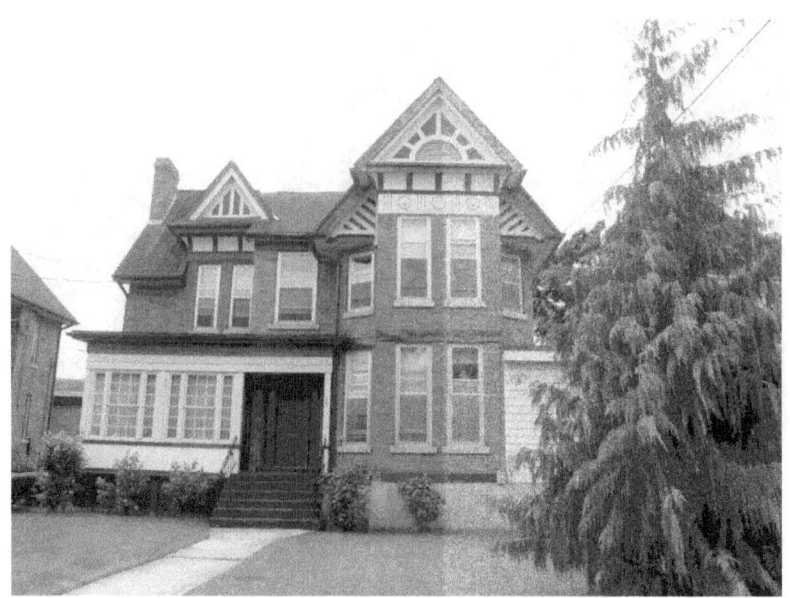

#261

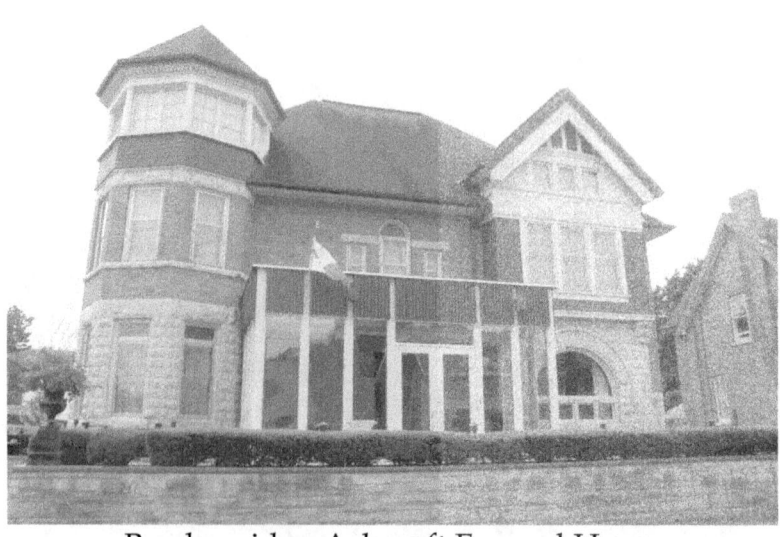

Breckenridge-Ashcroft Funeral Home
241 9th Street West

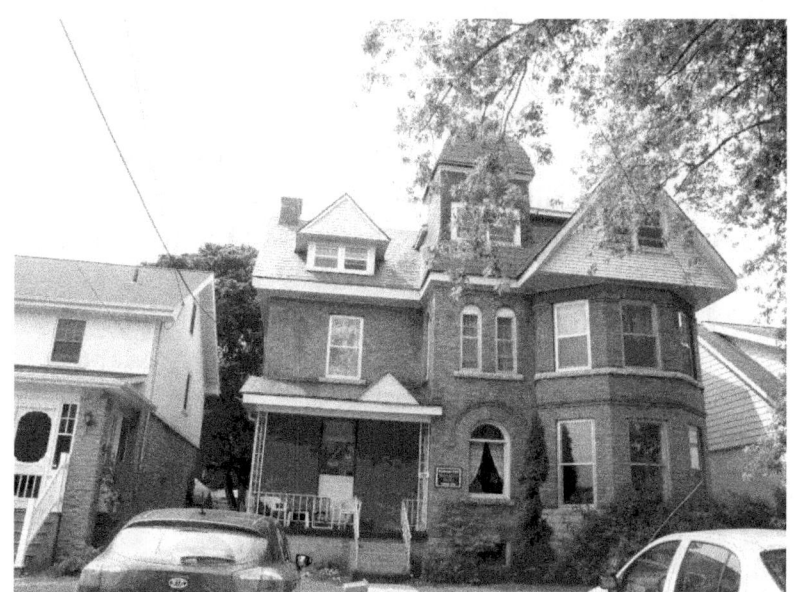

#281

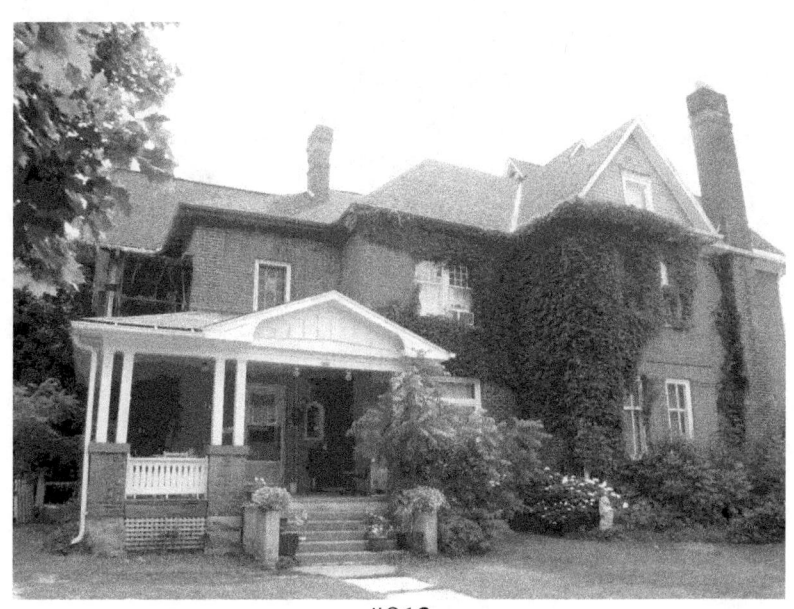

#913

The Photomosaic Project – celebrating 150 years of Owen Sound

This huge mural was unveiled on December 31, 2007. It depicts the Canadian one dollar bill; the currency features two boats which were built at Russell Brothers on the east side of the harbour. The Ancaster is the smaller of the two boats; it was built in 1951 and was used on the Ottawa River where it sank in 1979. It was raised in 1982 and restored; it was returned to Owen Sound in 1991 and is on display at the Owen Sound Marine & Rail Museum.

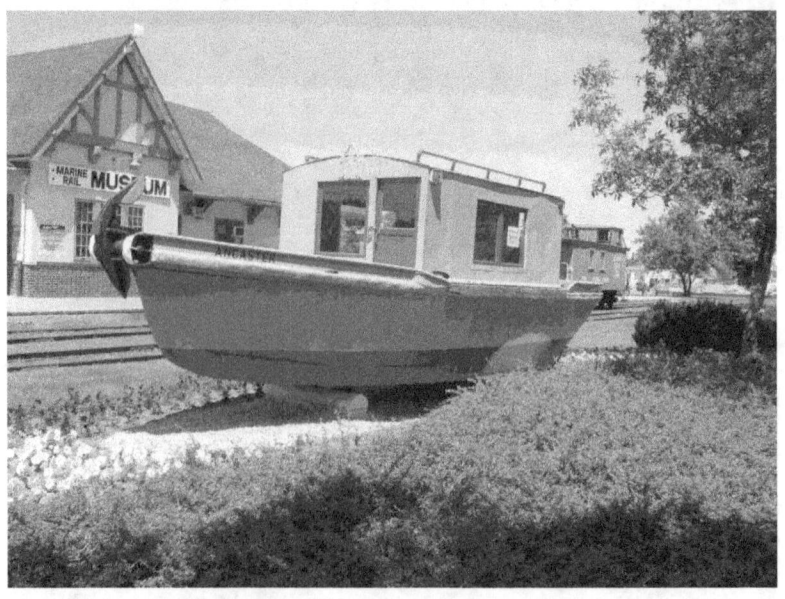

The larger boat, Missinaibi, was built in 1952 and served as a logging boat on the Ottawa River. It is on display at the Museum of Civilization in Hull.

The photomosaic was created by Will McReynolds using 363 photos of Owen Sounders and their families.

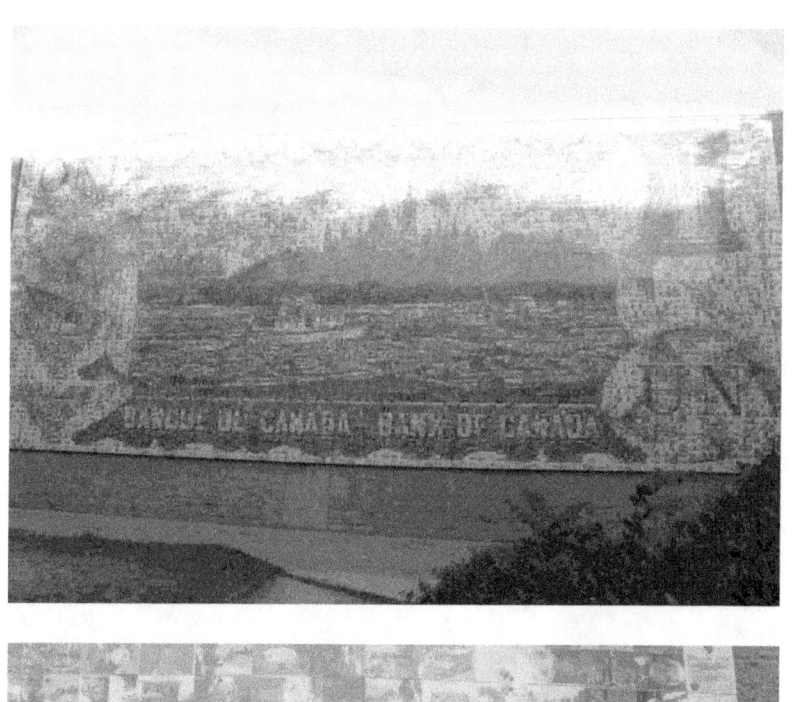
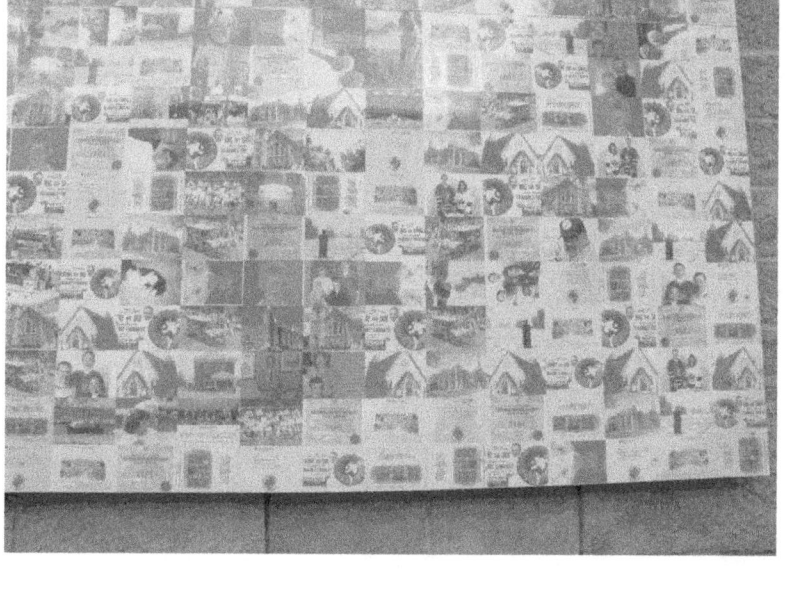

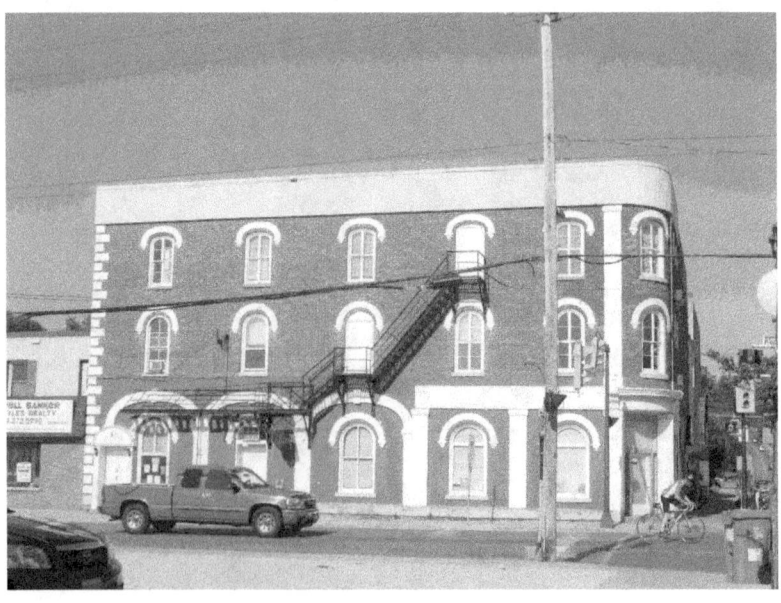

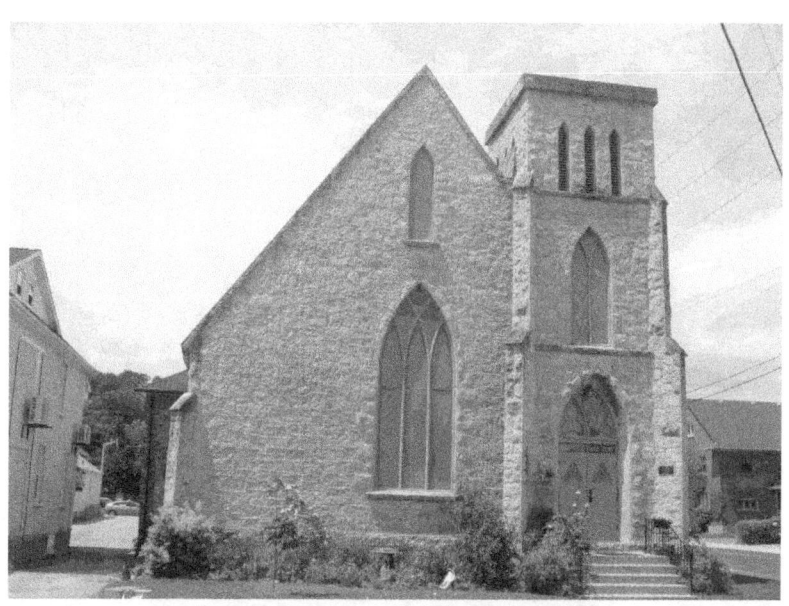

Congregational Church 1871
Women's Christian Temperance Union 1902
Our Saviour Lutheran 1942
Christian Science Society 1963

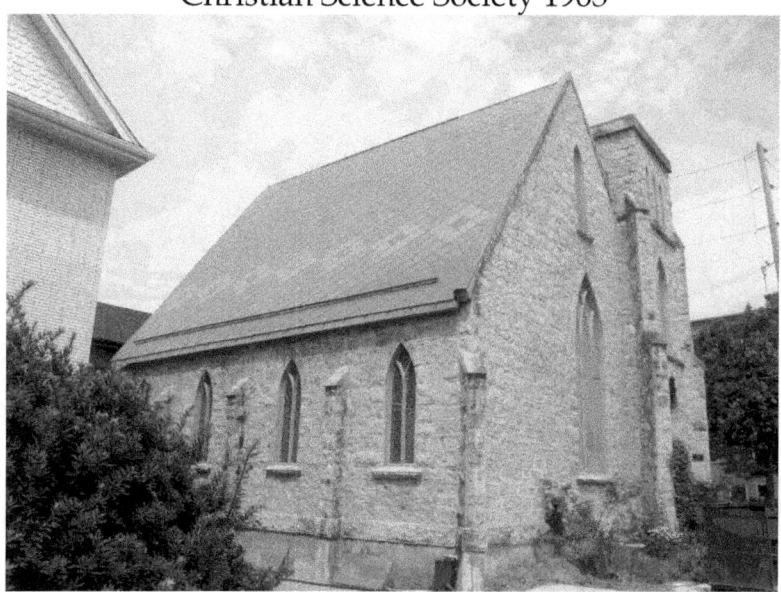

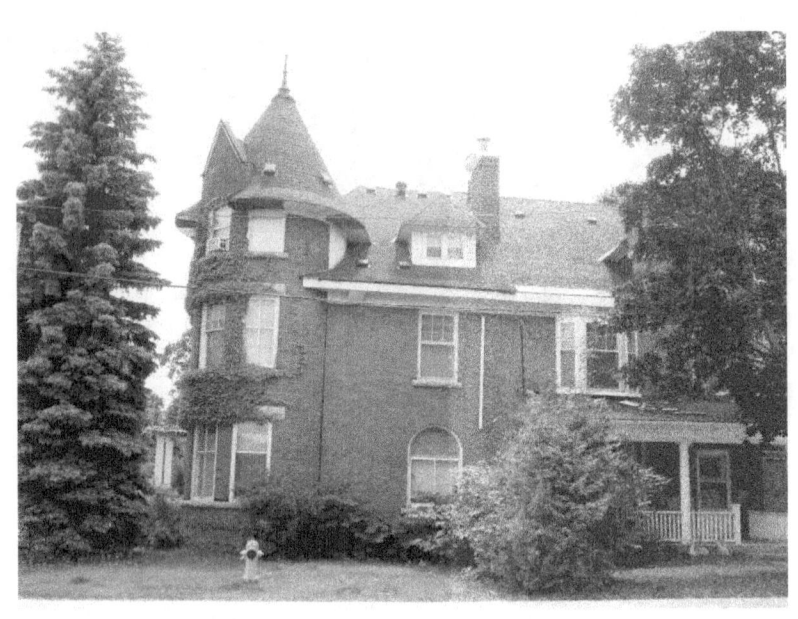

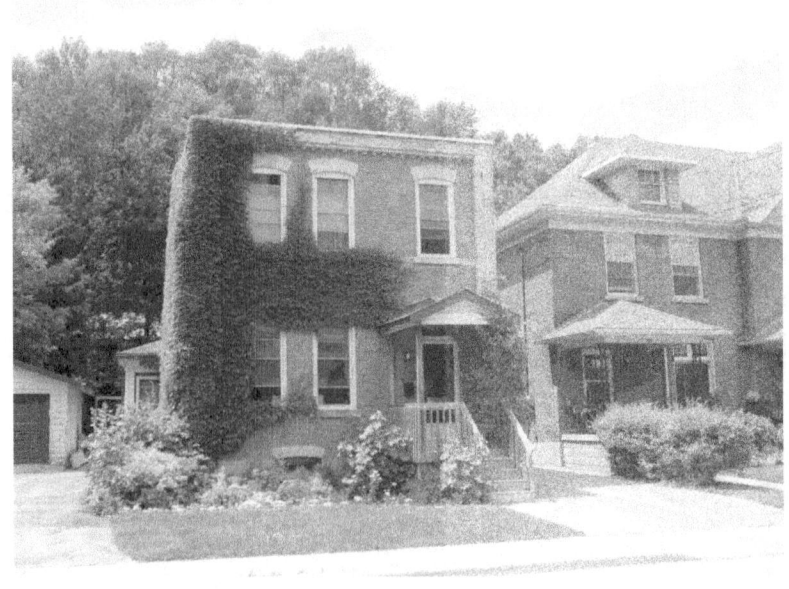

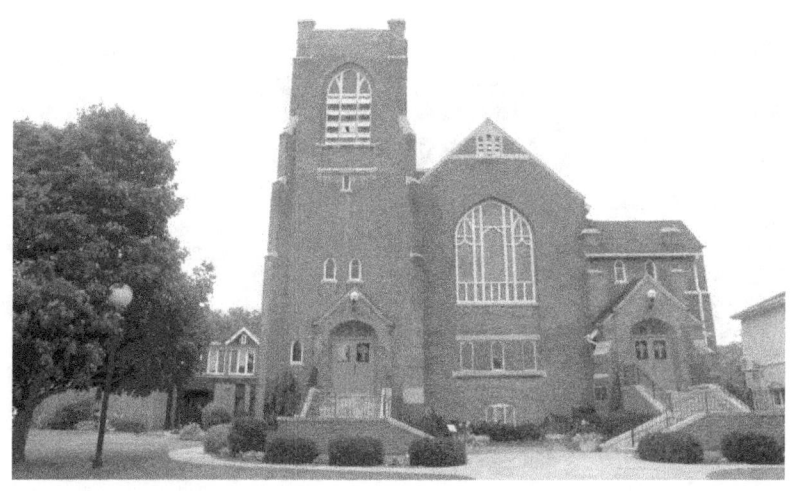

St. Andrews Presbyterian Church, 865 2nd Avenue West
Presbyterianism established in Owen Sound 1845 A.D.
Church corner stone A.D. 1926

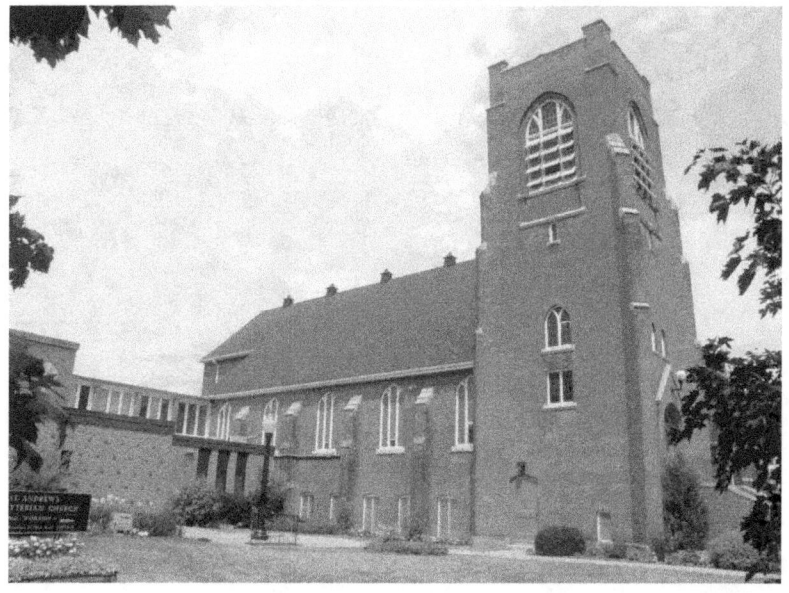

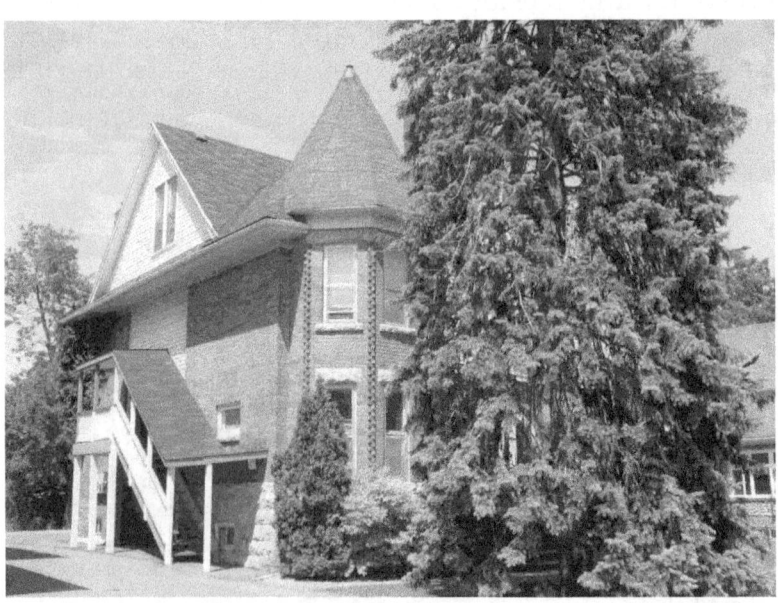

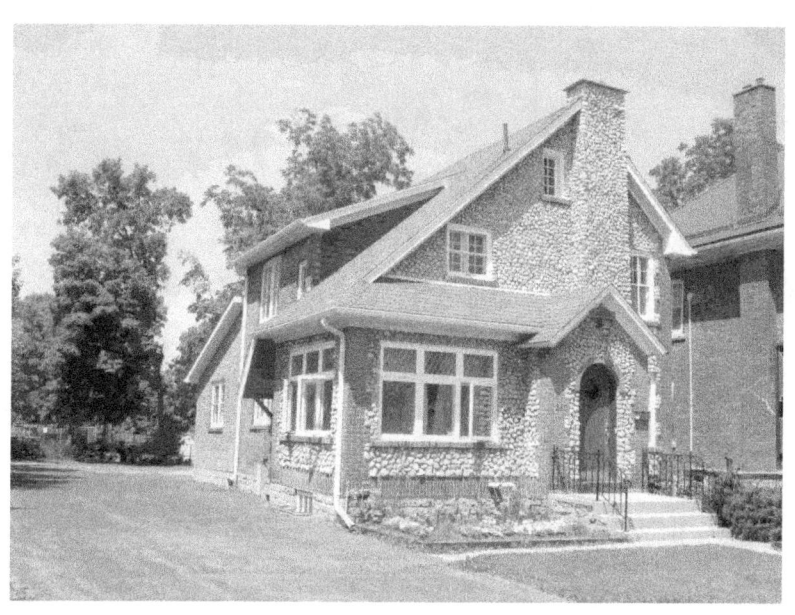

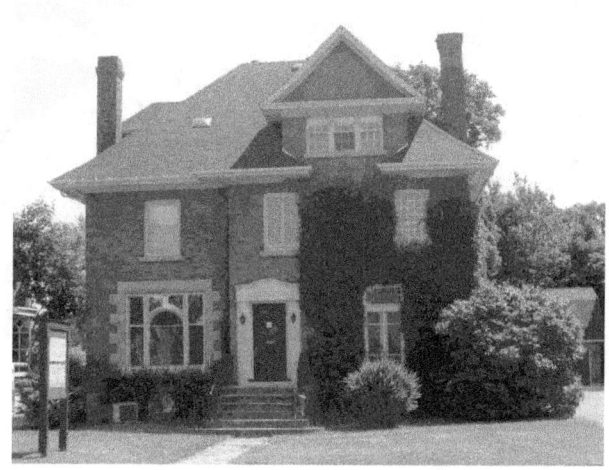

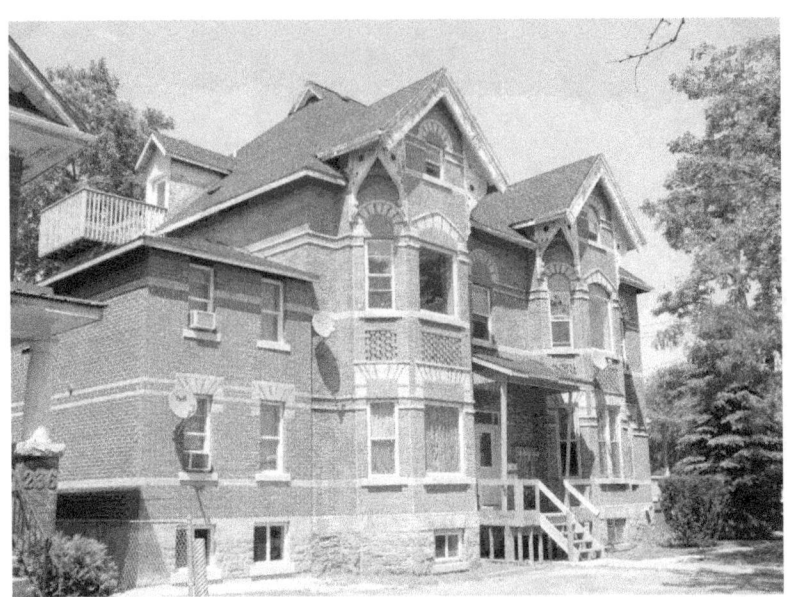

white brick accents

The intersection of 10th Street East and 4th Avenue East has a limestone church on each of the four corners.

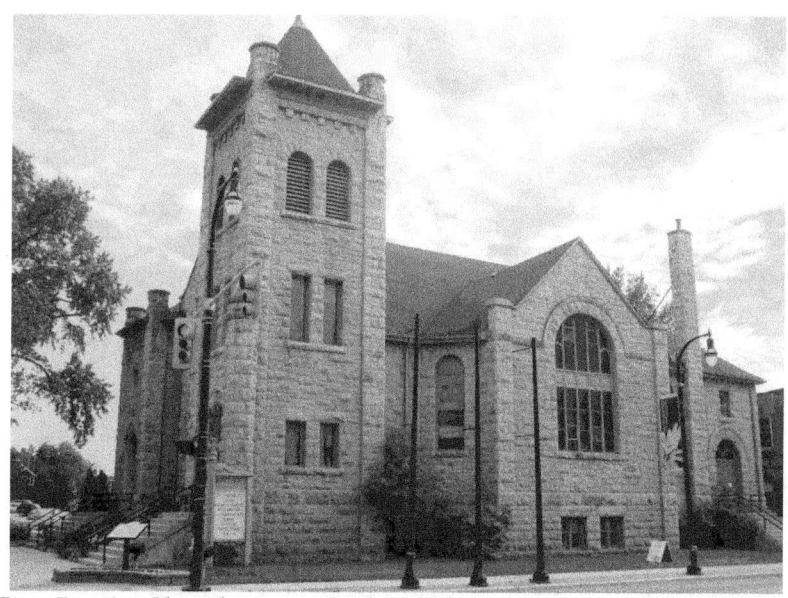

First Baptist Church – stone church built in 1903. The semi-elliptical windows are characteristic of the Italianate style. Square corner towers have octagonal caps.

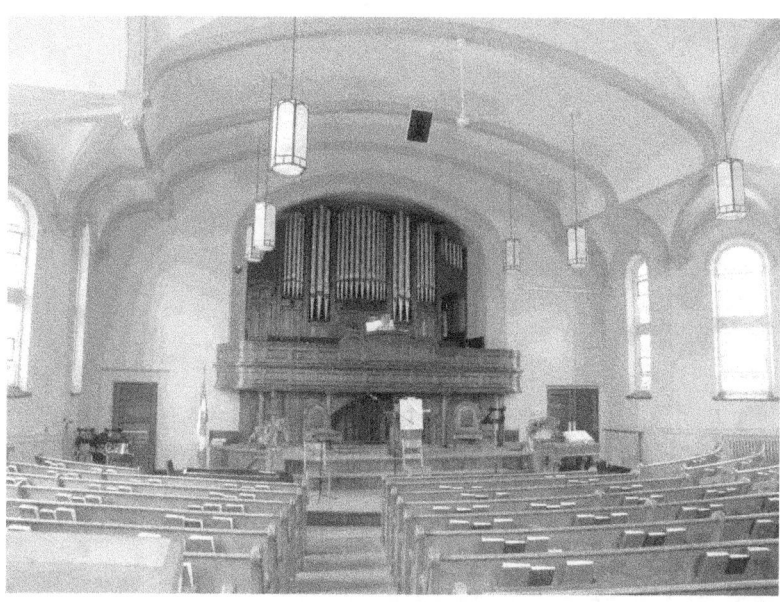

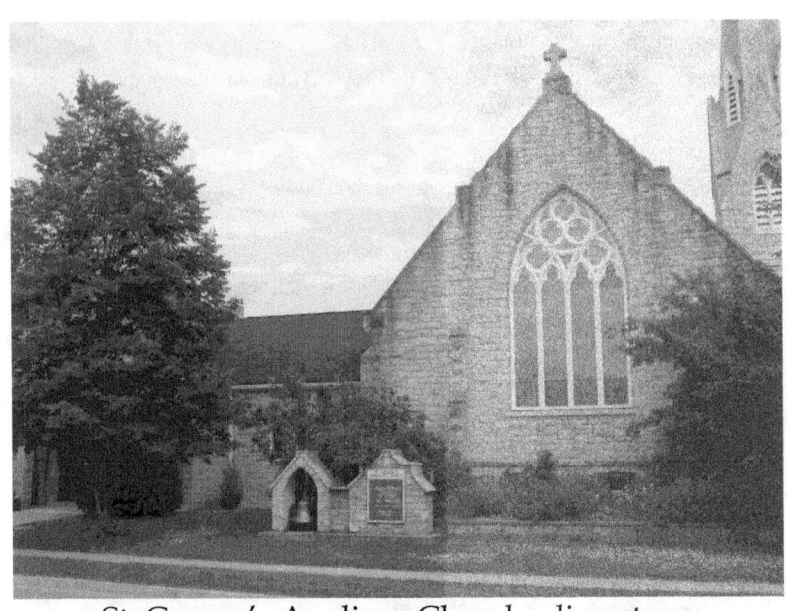

St. George's Anglican Church – limestone
construction\opened in 1881, enlarged in 1968, patterned after
St. Mary's Church, Bristol, England
in Gothic design – exterior window glazing and quatrefoil
(like a four leaf clover)

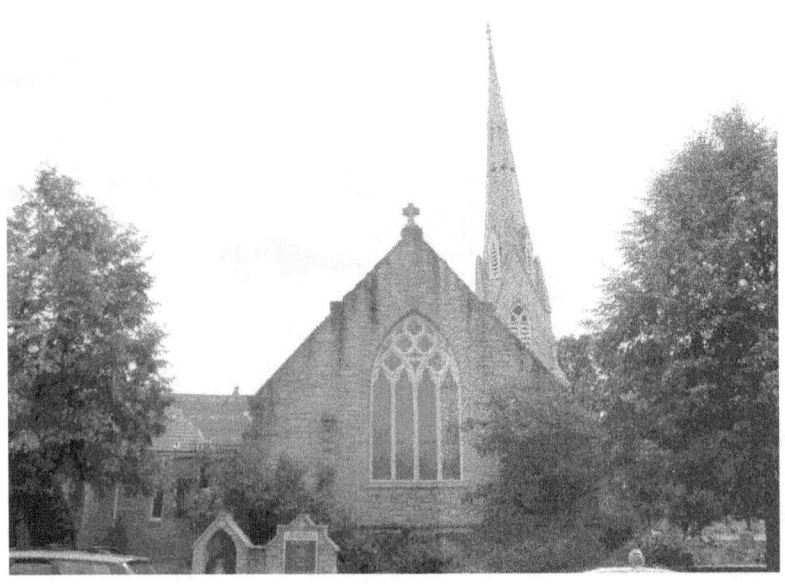

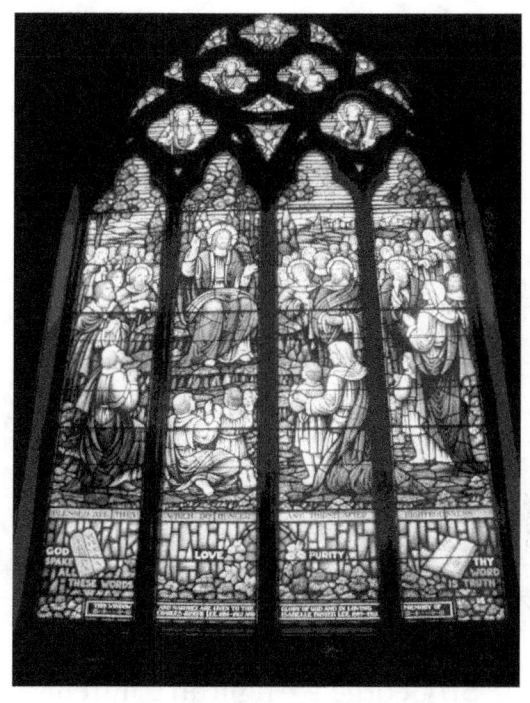

Inside St. George's Anglican Church

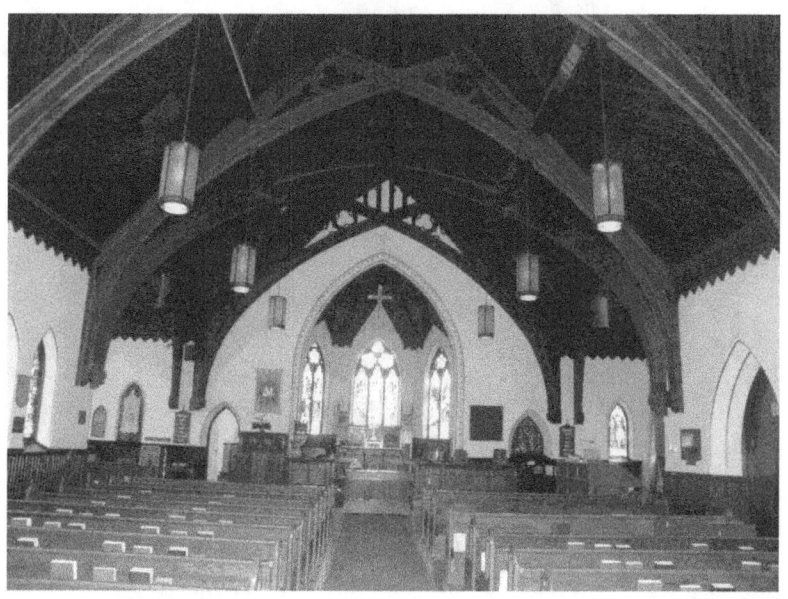

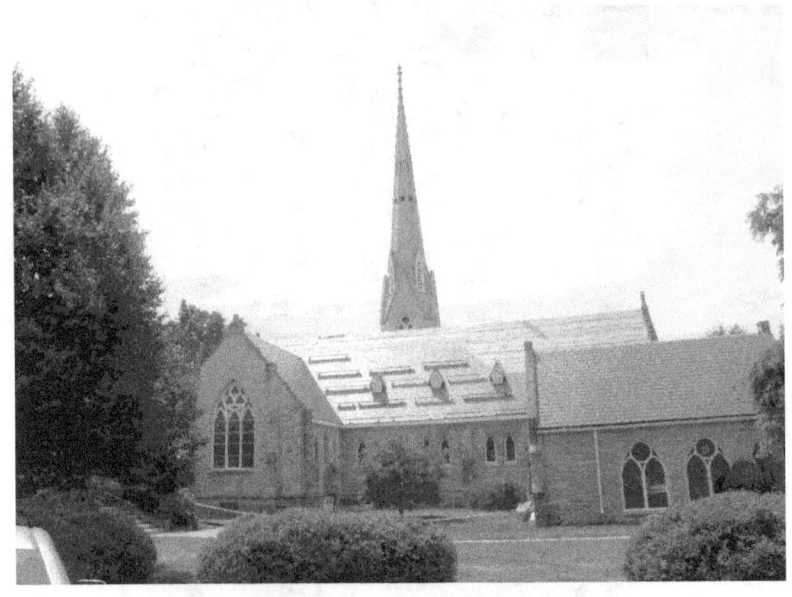

St. George's Anglican Church

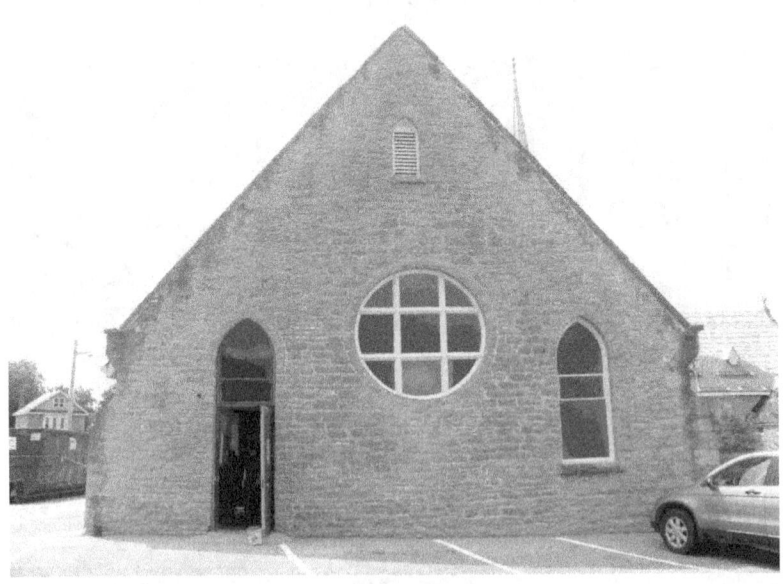

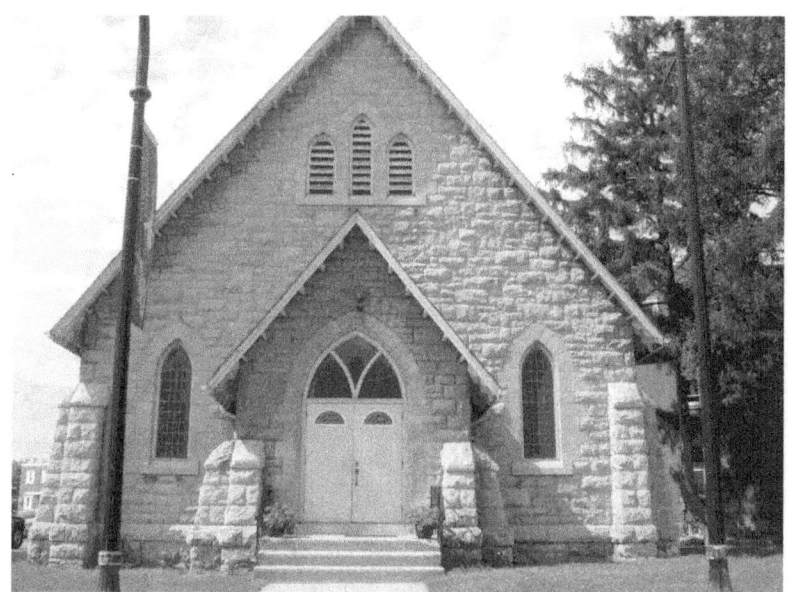

Stone church built by the Church of Christ, Disciples in 1889 in the early English country church style with a steeply pitched roof and sloping buttresses. Gables are cut into roof at the sides with two pointed arch windows. In 1956 this congregation was dissolved. The building was sold to The Church of the Nazarene who continue to use it today.

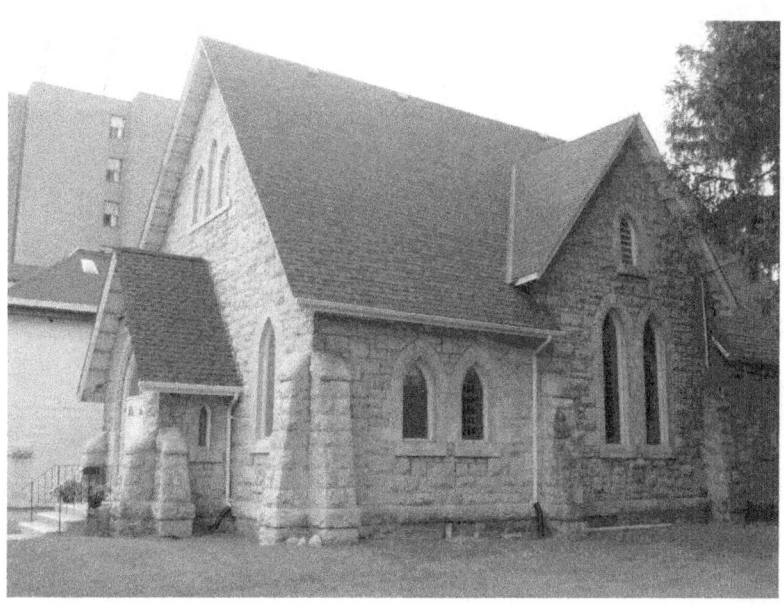

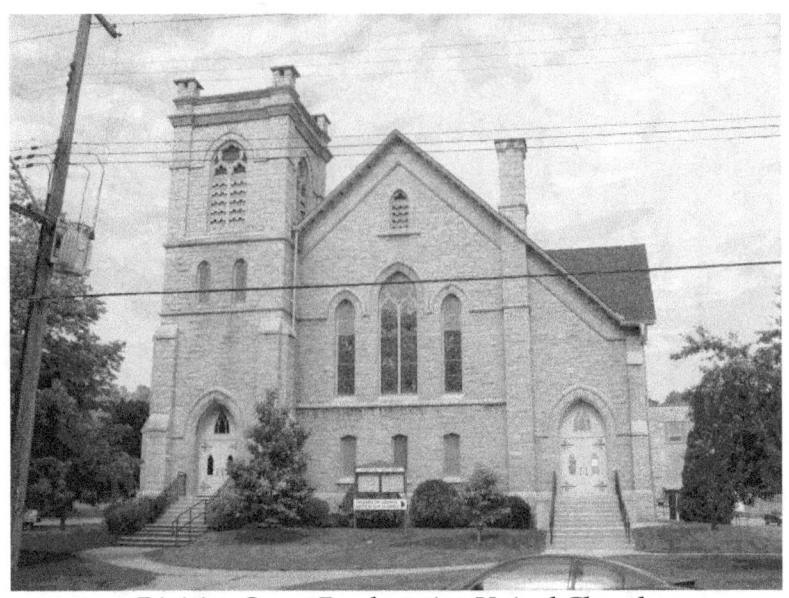

Division Street Presbyterian United Church
Built in 1886 in the Gothic Revival style
The windows are simple openings with pointed stone arches.
There is a square tower and stepped buttresses.

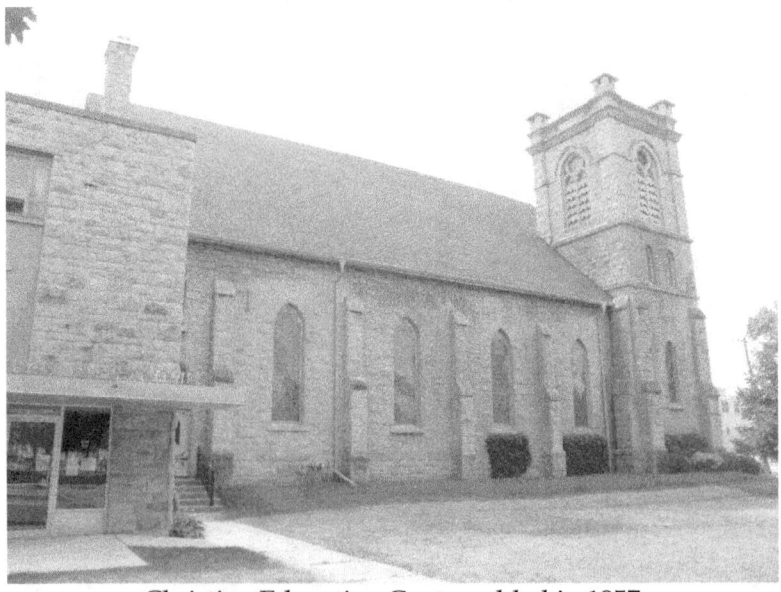

Christian Education Centre added in 1957

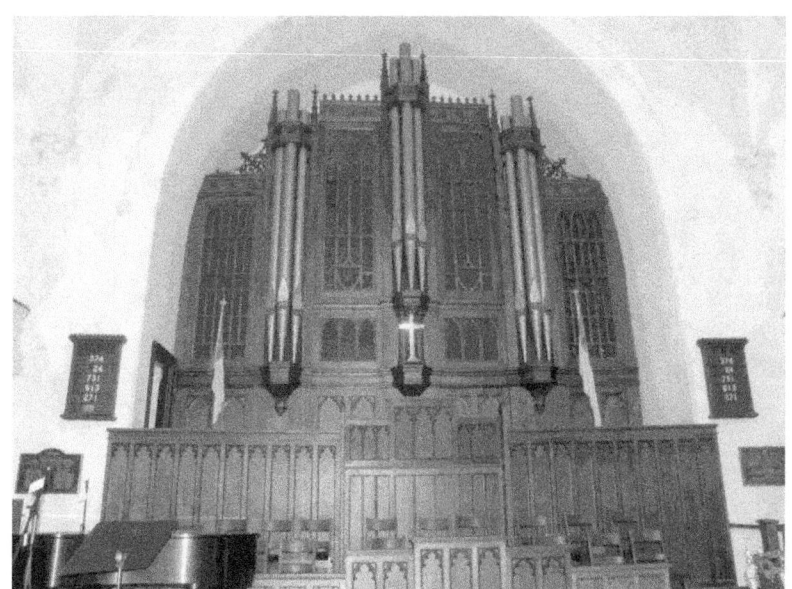

Inside United Church

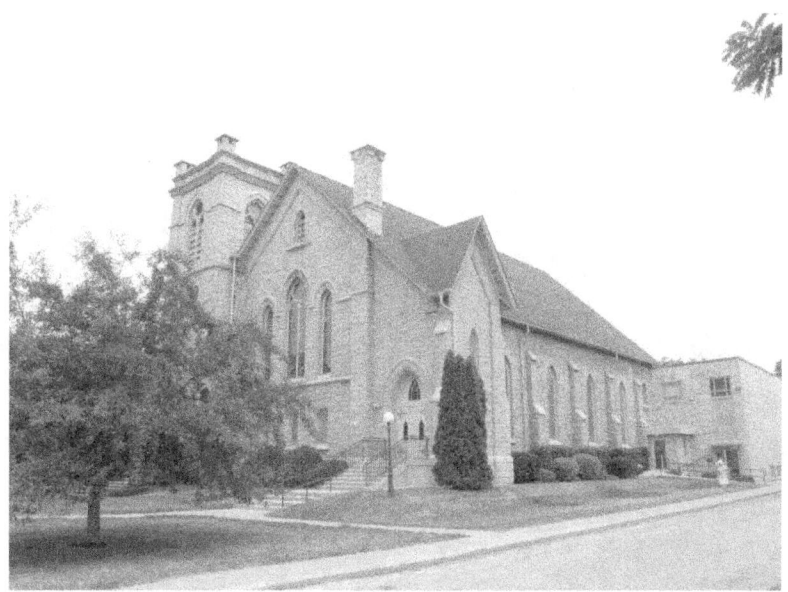

People's Department Store built in 1868

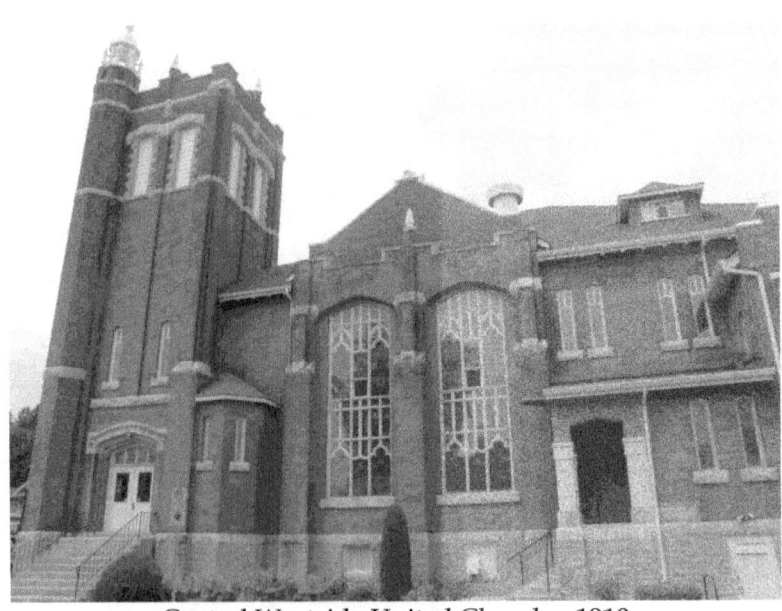
Central Westside United Church – 1910

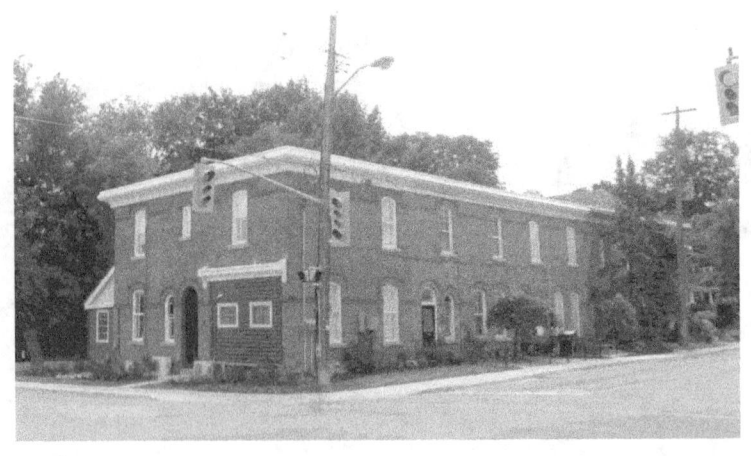

Round cupola

197 Eighth Street West

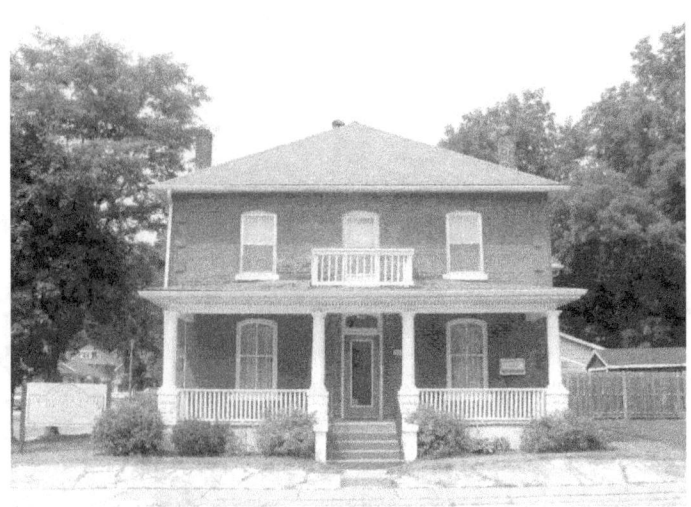
#804

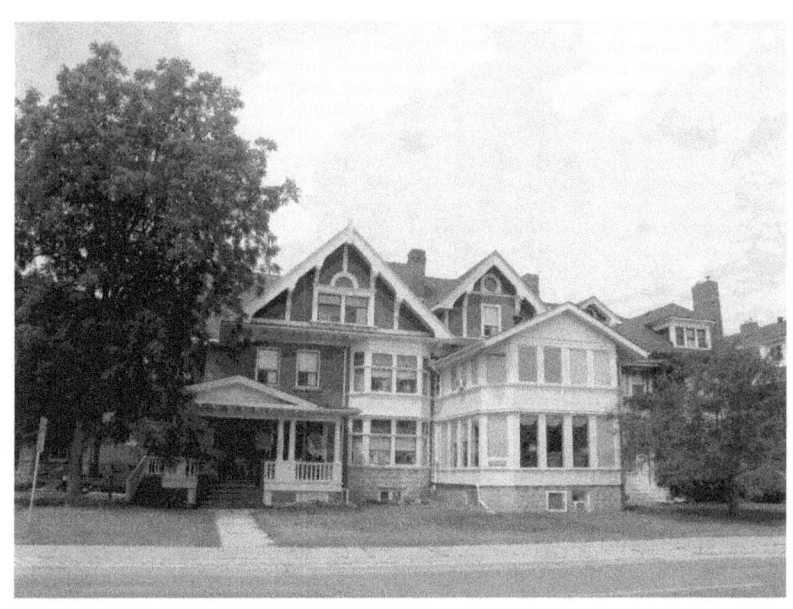

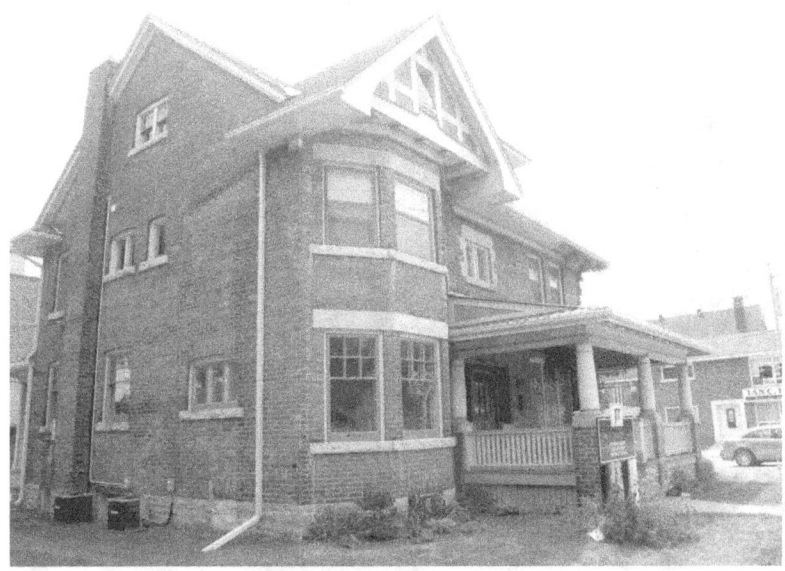

Wilkinson House – 1912

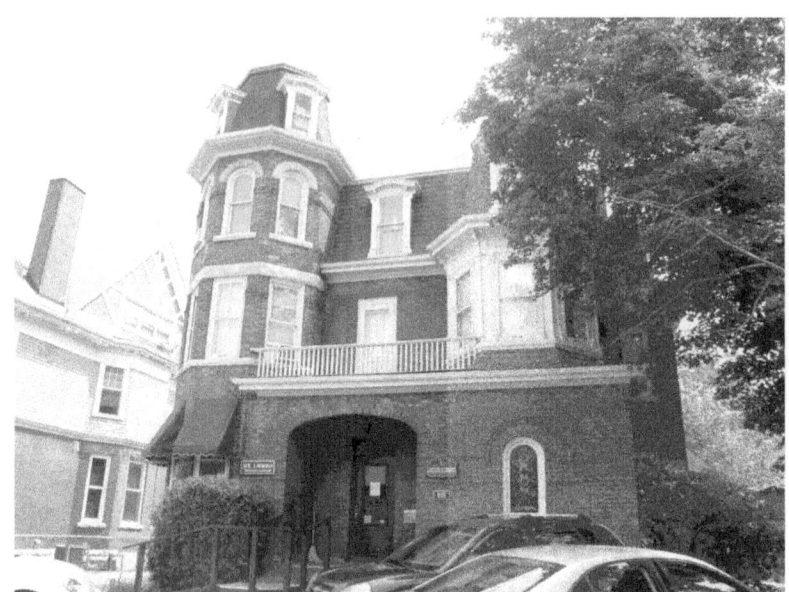

#935 – Law Offices – round turret

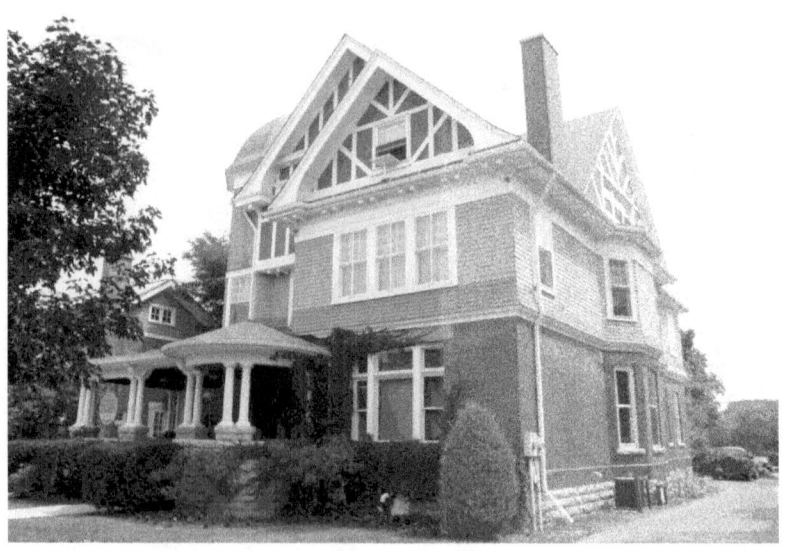

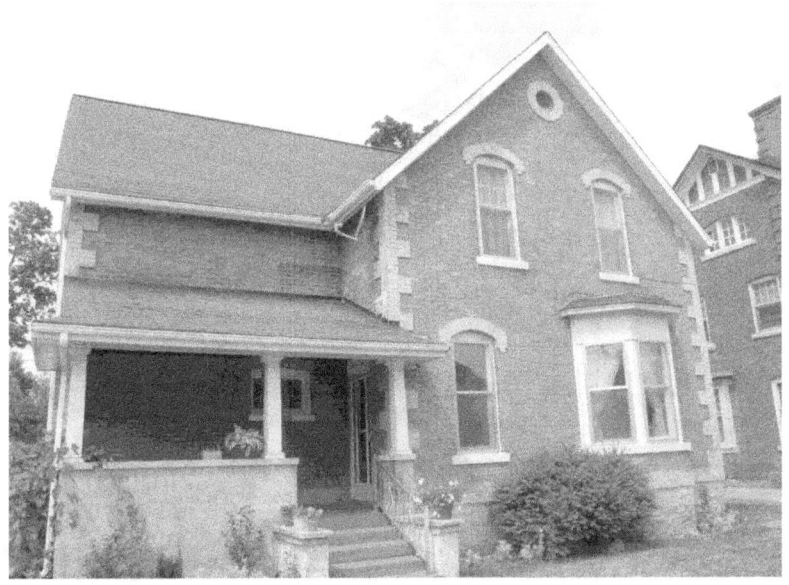

Gothic style arches, white brick accents

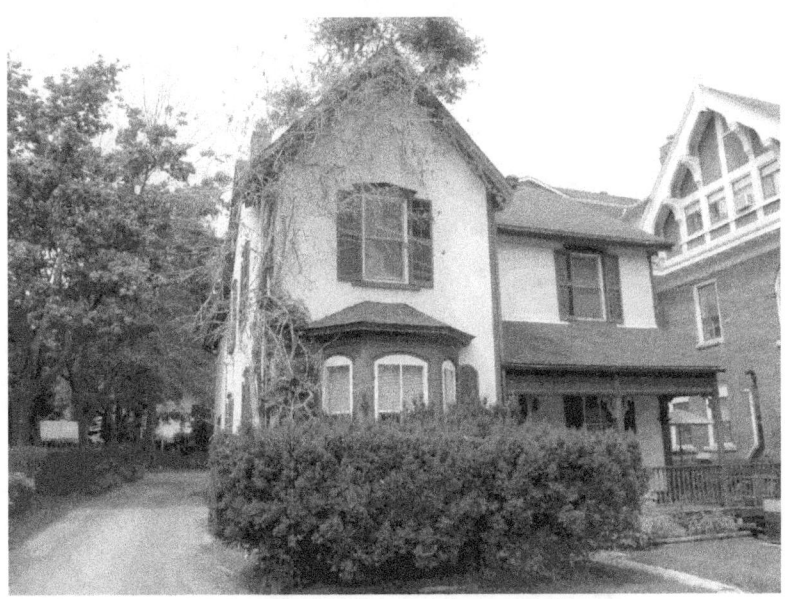

Retirement Home 2nd Avenue West

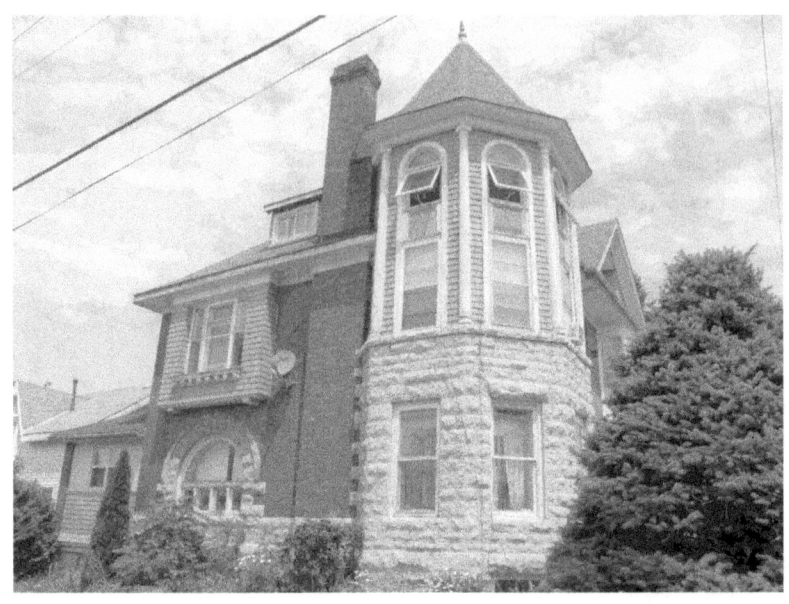

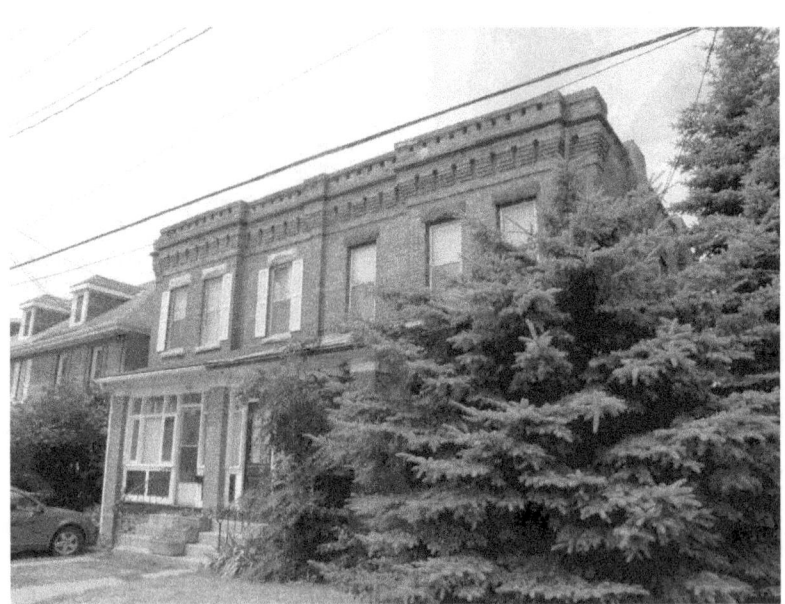

#1096

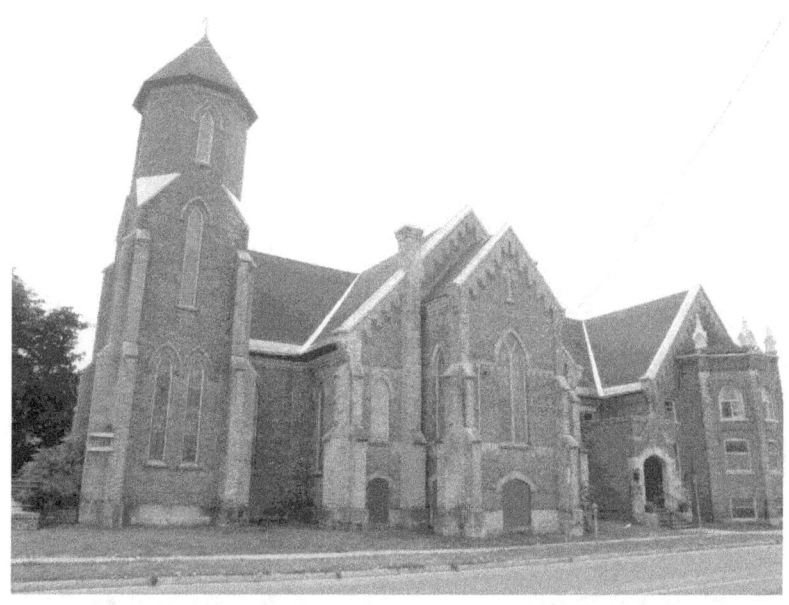

Knox United Church – now closed – beautiful rose window

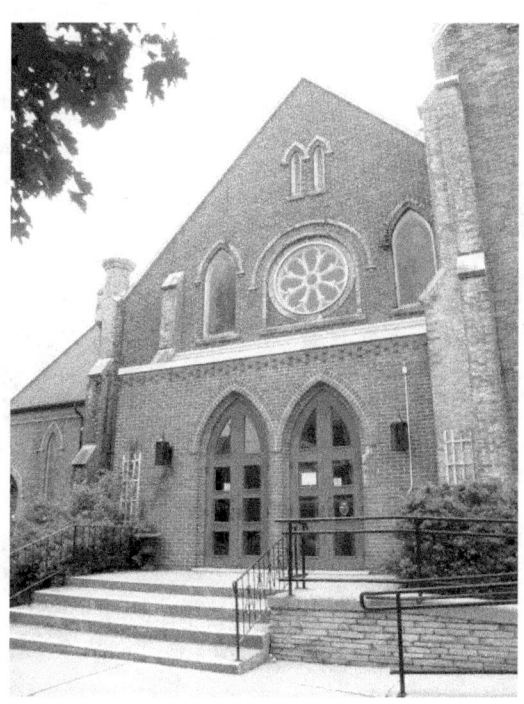

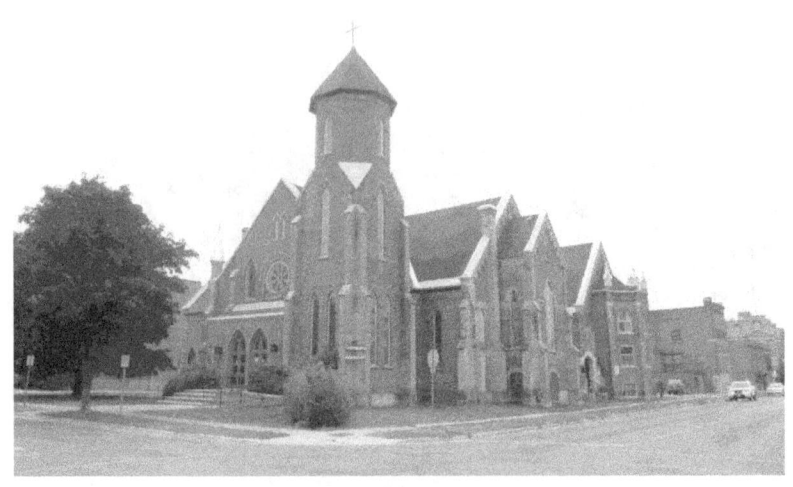

Knox United Church
9th Street East and 4th Avenue

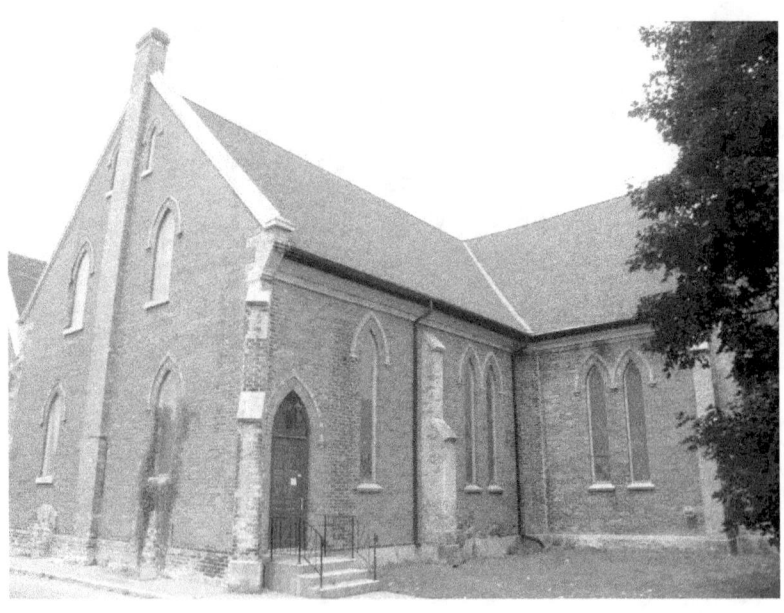

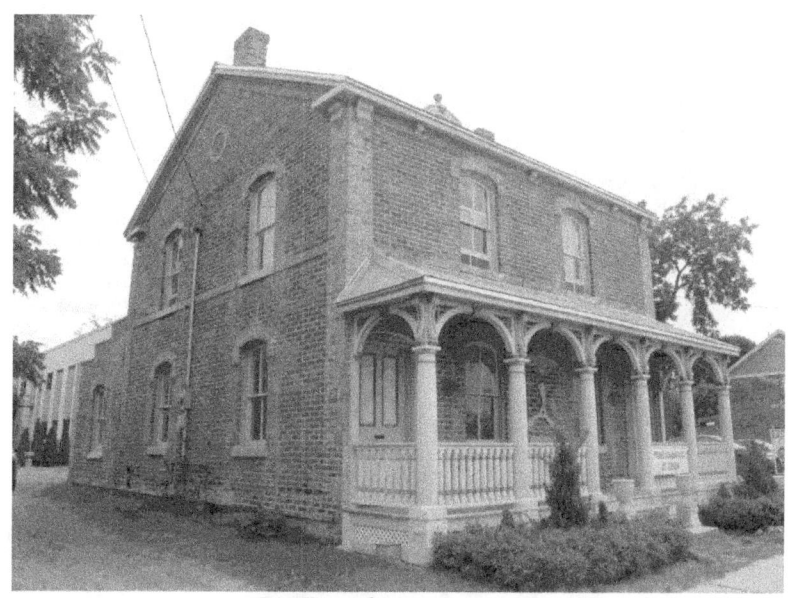

961 Fourth Avenue East

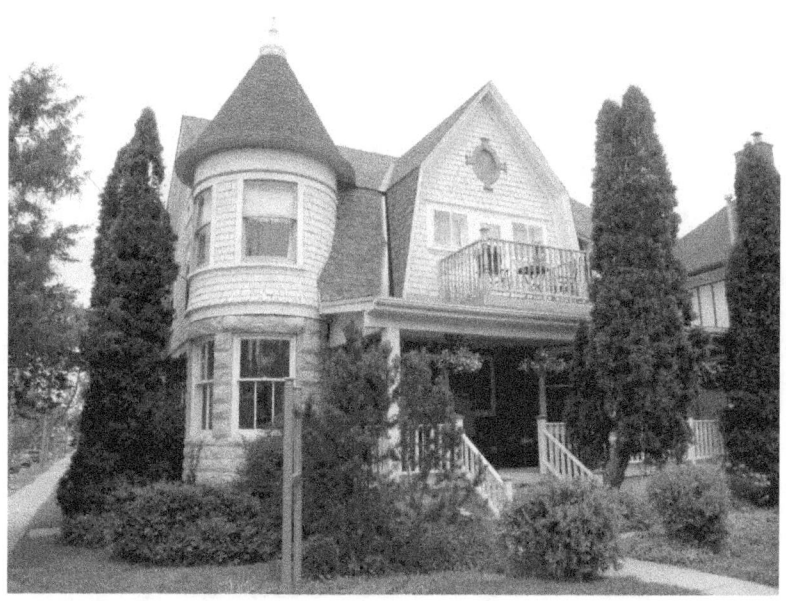

9th Street East and 4th Avenue

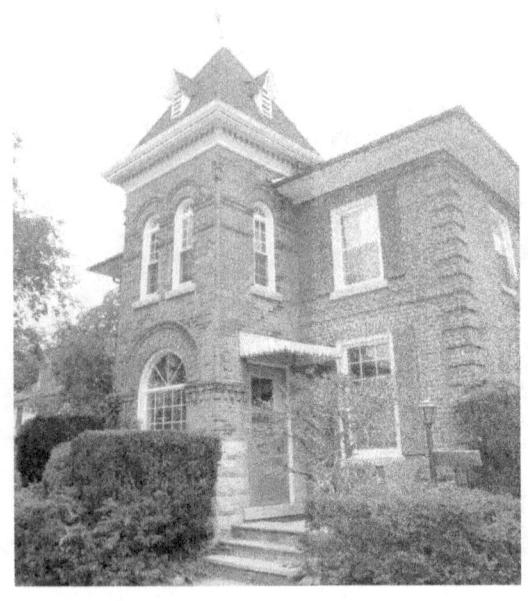

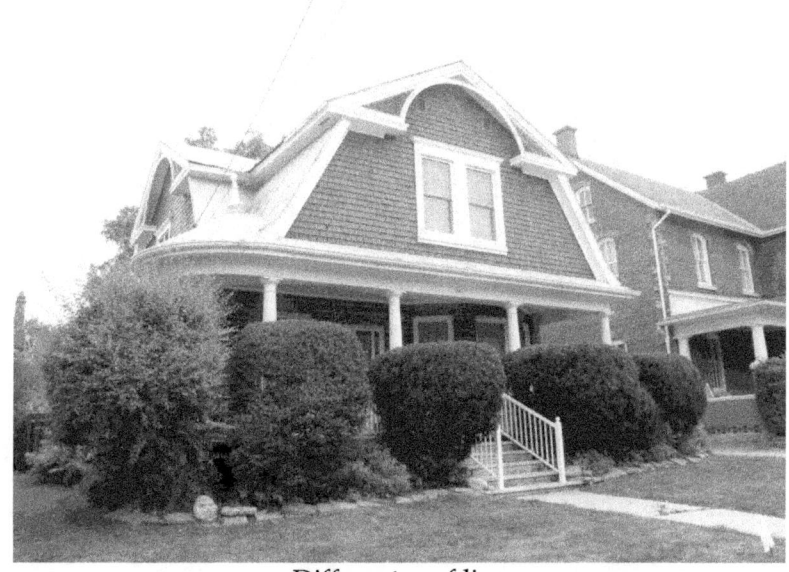

Different roof line

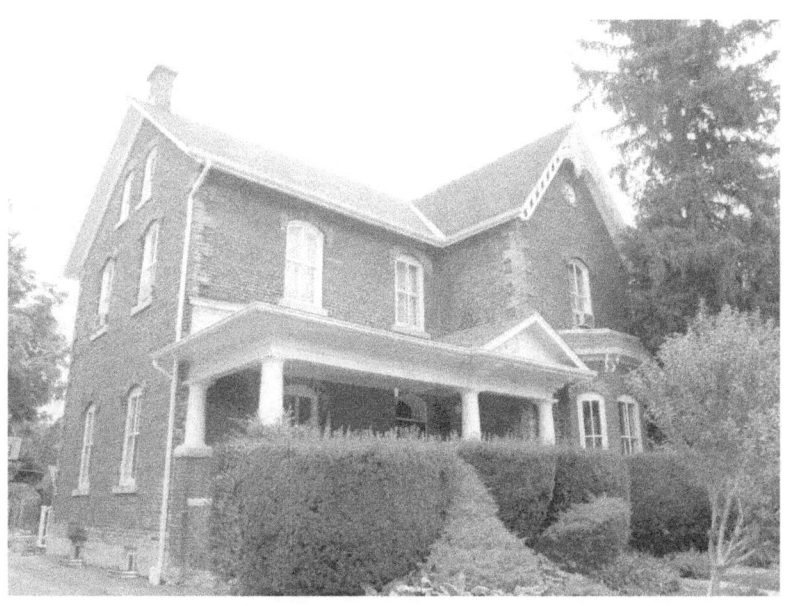

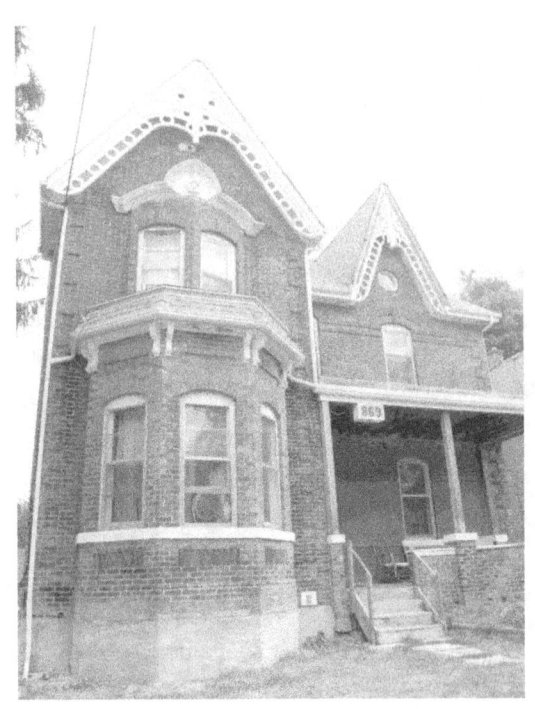

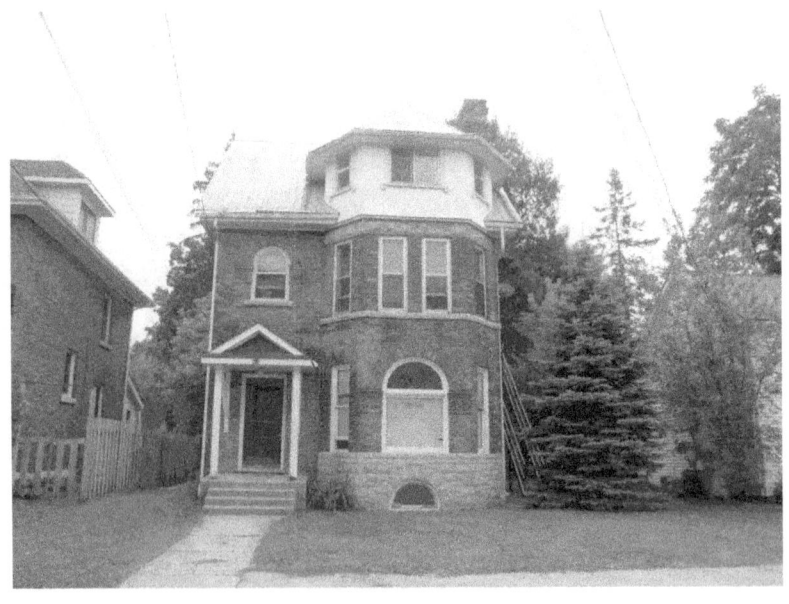

5th Avenue East and 8th Street East

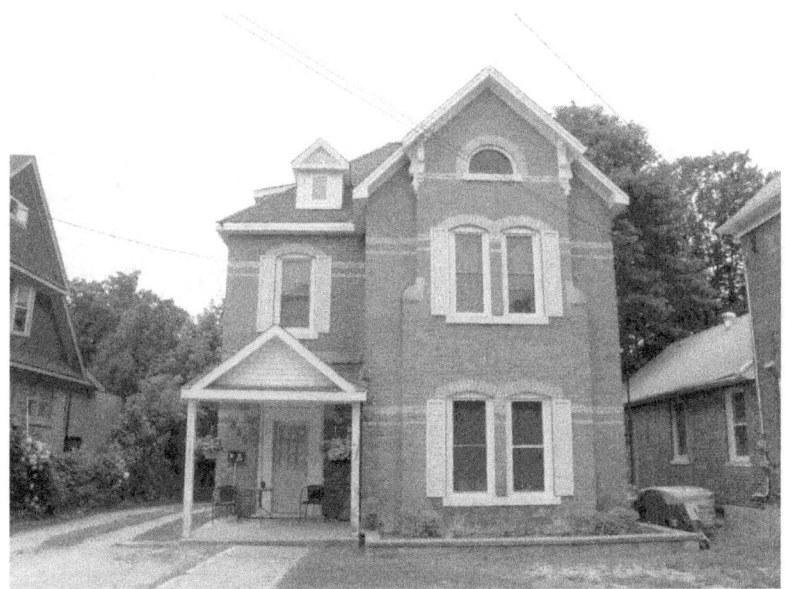

#844

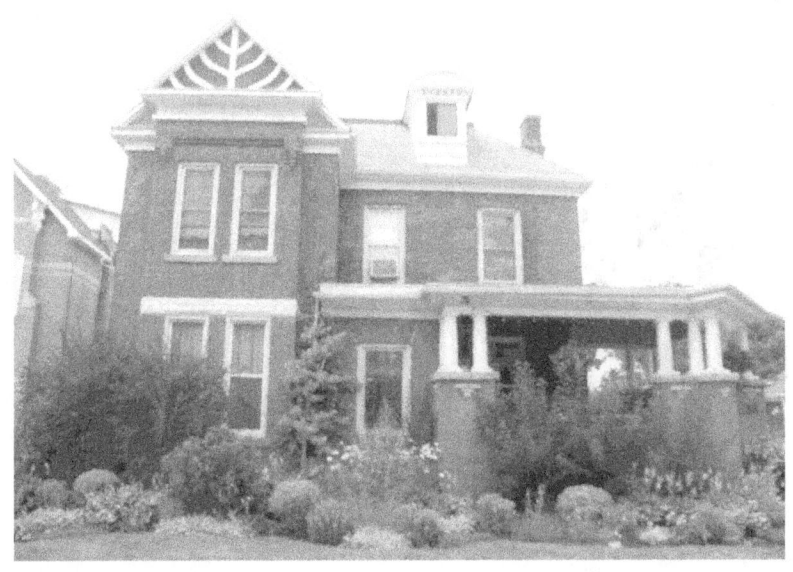

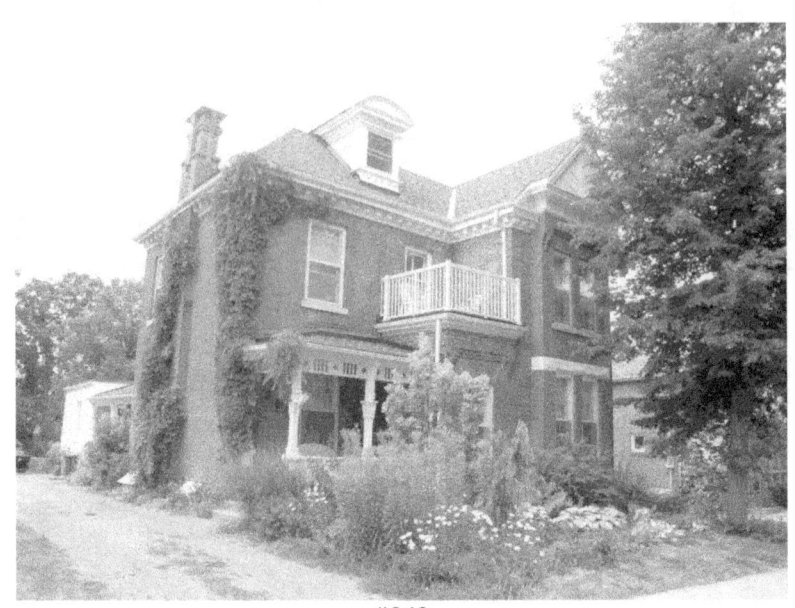

#862

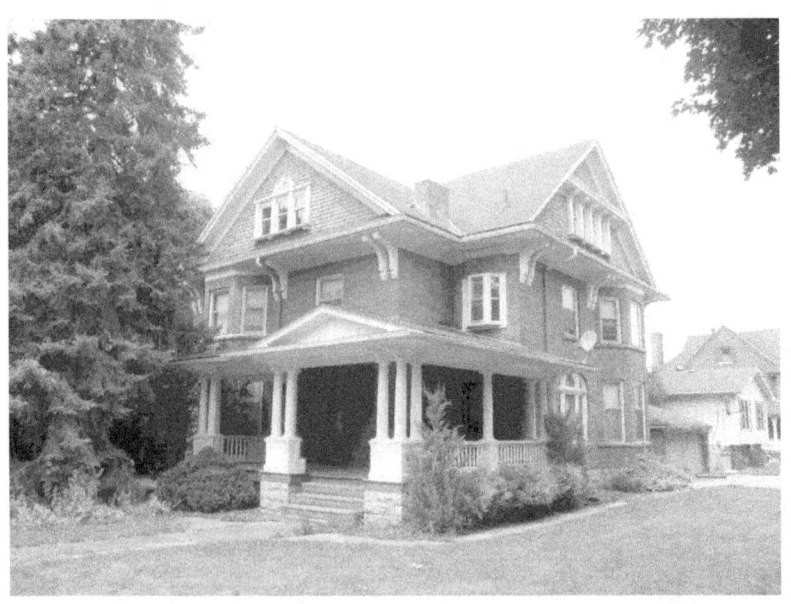

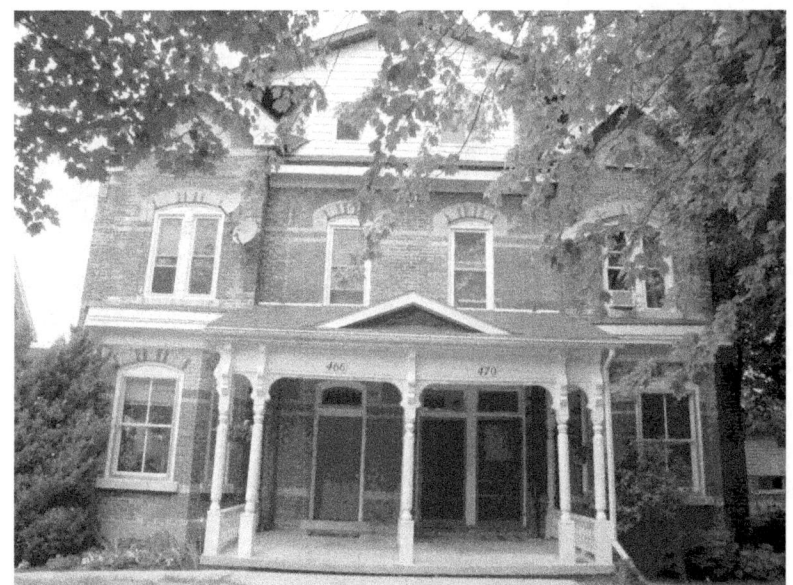

#466 and #470

#452 – Gothic style arches and vergeboard trim

9th Street East 5th Avenue East

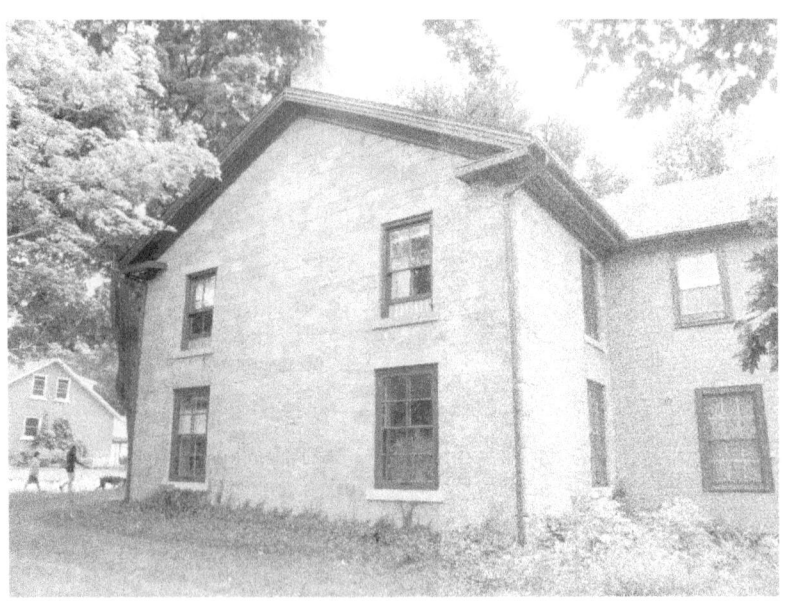

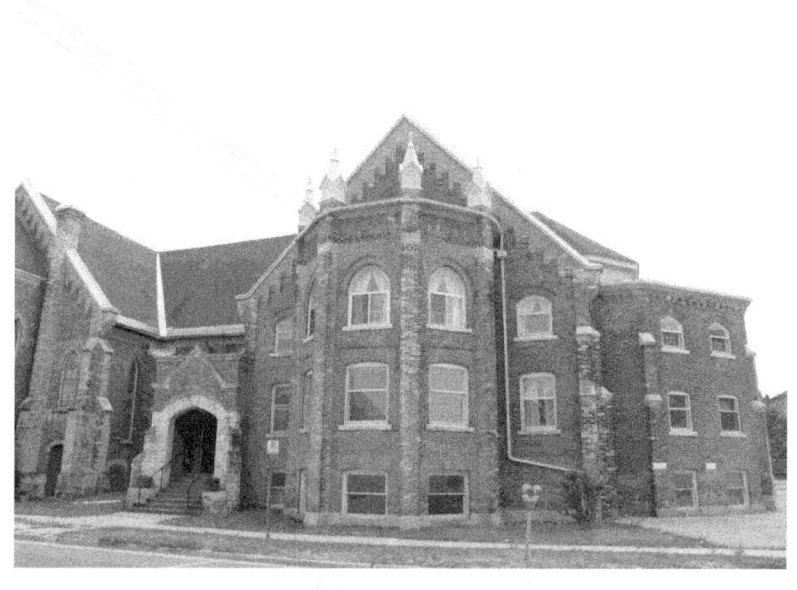

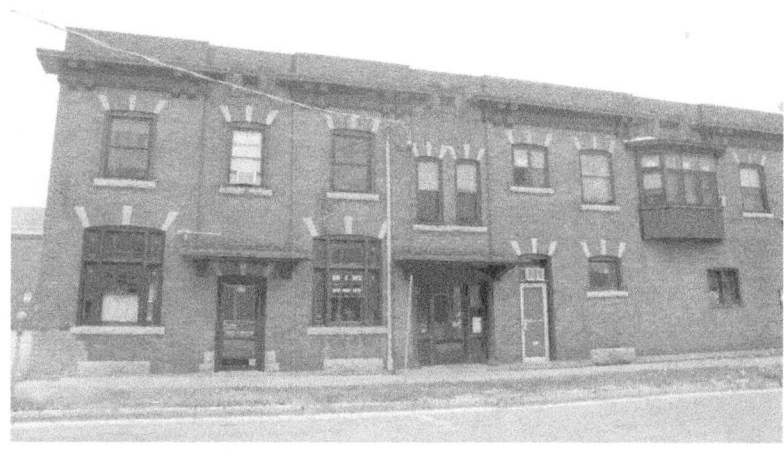

9th Street East, 3rd Avenue East

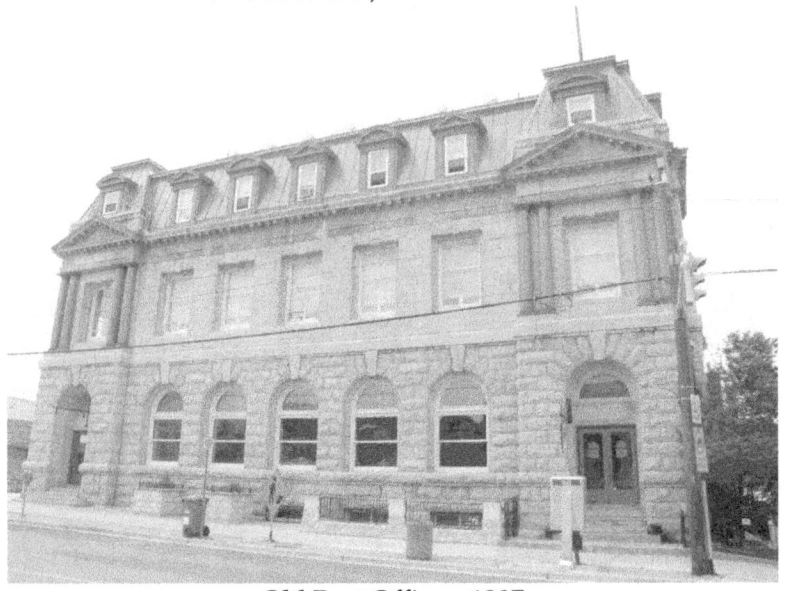

Old Post Office – 1907

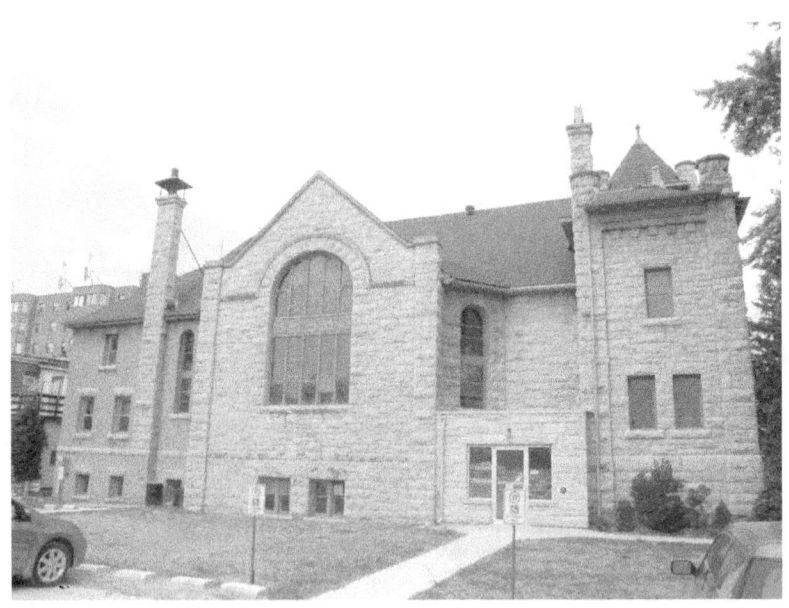

www.ingramcontent.com/pod-product-compliance
Lightning Source LLC
Chambersburg PA
CBHW061518180526
45171CB00001B/229